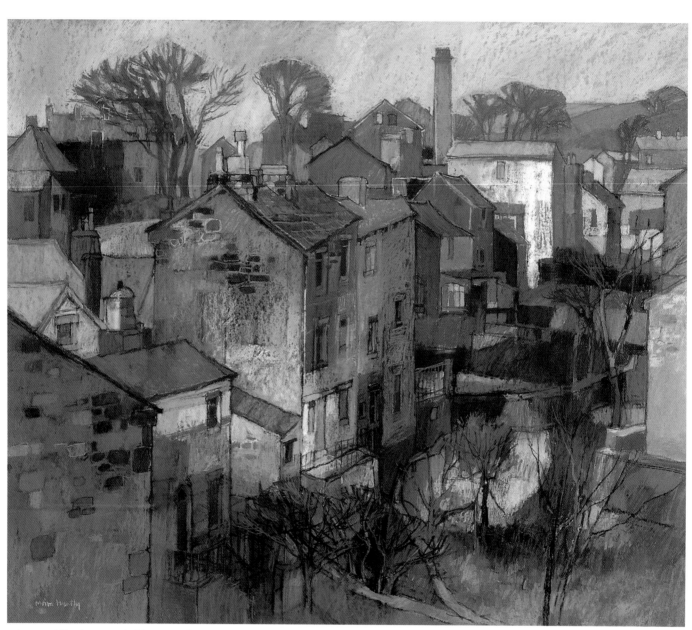

Winter Addingham, Yorkshire; pastel 70 x 80cm (28 x 32in)

MOIRA HUNTLY'S
SKETCHBOOK SECRETS

David and Charles

Title page: Cumbria, England, 2B pencil

A DAVID & CHARLES BOOK
David & Charles is a subsidiary of F+W (UK) Ltd.,
an F+W Publications Inc. company

First published in the UK in 2005

Distributed in North America
by F+W Publications, Inc.
4700 East Galbraith Road
Cincinnati, OH 45236
1-800-289-0963

A catalogue record for this book is available from the British Library.

ISBN 0 7153 1933 7 hardback
ISBN 0 7153 1934 5 paperback (USA only)

Printed in China by R R Donnelley
for David & Charles
Brunel House Newton Abbot Devon

Commissioning Editor Mic Cady
Desk Editor Lewis Birchon
Designer Lisa Wyman
Production Controller Kelly Smith

Visit our website at www.davidandcharles.co.uk

David & Charles books are available from all good bookshops; alternatively
you can contact our Orderline on (0)1626 334555
or write to us at FREEPOST EX2 110, David & Charles Direct, Newton
Abbot, TQ12 4ZZ (no stamp required UK mainland).

Totem Pole, Vancouver, Canada, pen and ink

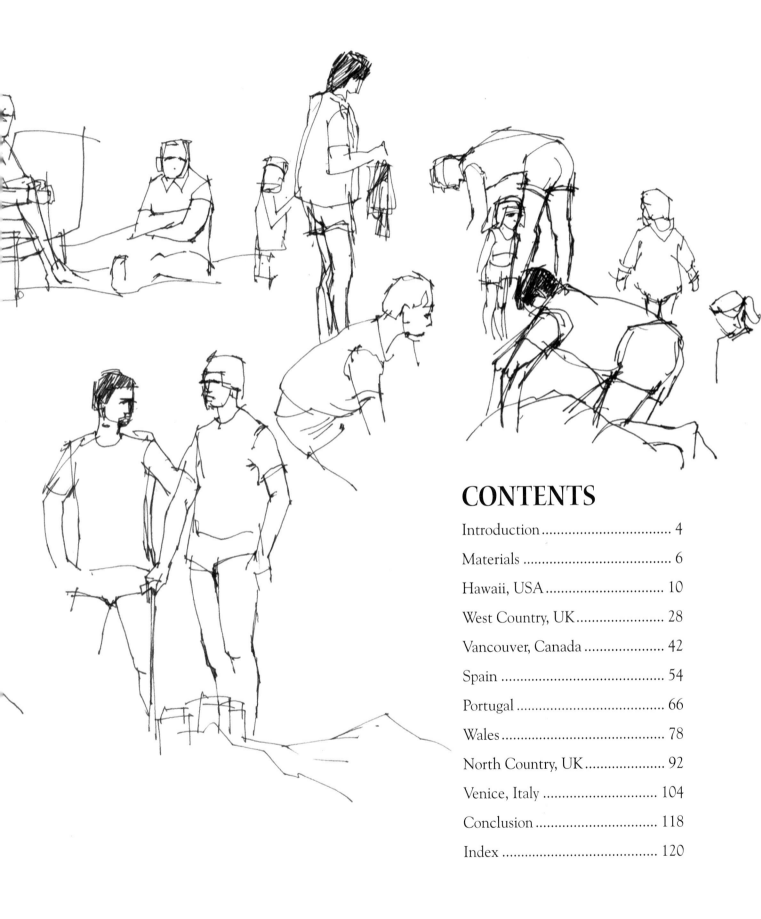

CONTENTS

INTRODUCTION

Sketchbooks are personal and intimate, often revealing the individuality of the artist; this is fascinating for the viewer who likes to share these inner thoughts. For the artist a sketchbook is essential, providing a fund of ideas and information and, above all, the inspiration for future paintings.

In *Sketchbook Secrets* I share my initial thinking and working procedures, selecting a point of view, where to start a complicated subject, the hazards to look for when sketching, and the materials I take with me. I also pass on plenty of tips gained from many years of drawing. The book is planned around the sketches made during my travels, and some of the resulting paintings. I describe how I interpret my sketches as paintings by extracting the elements that attracted me most, selecting shapes and patterns that intensify the vision, sometimes discarding parts of a sketch to create a painting that is not merely a reproduction.

I enjoy travelling in search of places to draw and paint and never go on a holiday without some form of sketching equipment, however minimal; in fact a pocket sketchbook is useful to have handy for the unexpected opportunity. Inevitably, we all spend time waiting at airports and stations, so being able to make a few quick sketches relieves the tedium. I also keep a sketchbook with me in the car. I passionately believe that drawing is seeing and that anyone who wants to can learn to draw, though drawing is not easy, and artists, like musicians, need to develop their skills. The co-ordination of hand and eye will come with practice and perseverance.

Being able to sketch is a wonderful means of recording a holiday in an individual – as opposed to a photographic – way, and the addition of notes and anecdotes can create a really interesting visual diary. In the past, when I was on holiday with the family, I tended to do little in the way of drawing and painting until a friend pointed out that I could easily take time out to make quick sketches, and the family wouldn't mind waiting 15 or even 30 minutes while I did so. On my last long haul trip to see family this proved to be true and I was able to fill a sketchbook with drawings and notes; it became a visual diary, some of which I have included in this book.

Working at speed can be a good thing; it can sharpen and concentrate the vision and give a freedom to the line because you are drawing naturally and there is no time to think about technique. The result can often be a drawing full of life and energy.

The idea of recording travels with a sketchbook is not new. In the 18th century it was fashionable to make the 'Grand Tour' and make many topographical drawings and

Rupit, Spain, charcoal pencil

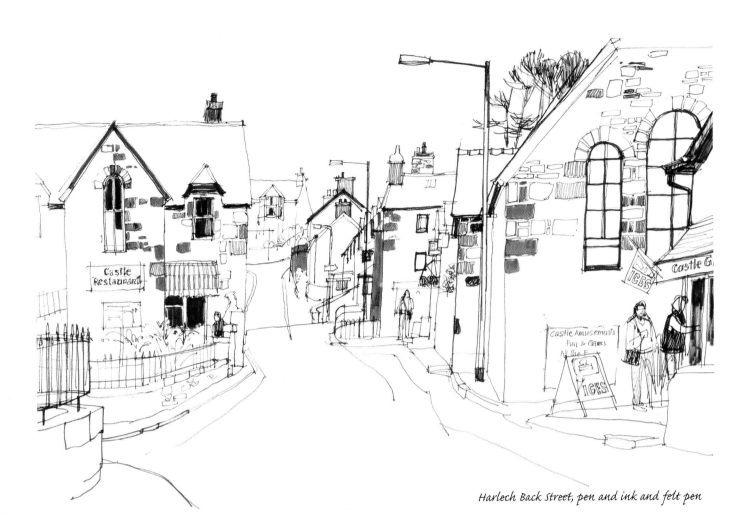

Harlech Back Street, pen and ink and felt pen

watercolours. Turner undertook the first of his numerous sketching tours of foreign parts in 1792, and in those days transporting equipment was fraught with difficulties.

Today travel is easy. By car you can include as much equipment as you like, though the amount carried when travelling by air is more limited. However, excellent results can be achieved with a minimum of equipment – although in the end, it is always a personal choice.

Added to the difficulties of drawing on location are the many hazards to overcome, such as weather, insects, animals and chatty people, especially children; so concentration is required.

Included in this book are many of the places in the world that are visually attractive to me, and some of these places also have a connection with my past.

Spain and Portugal are associated with early childhood memories. I lived in Spain until the outbreak of the civil war when my parents and I were rescued by the British navy and taken to Portugal. My first holiday in Britain,

when I was about five years old, was to North Wales, and I particularly remember the excitement of a pre-war car ride to Snowdonia. It was cold and misty as we climbed to higher ground, and we stopped at an inn for my very first packet of crisps with its novel blue paper twist of salt. When my own family were growing up, we spent holidays on the Pembrokeshire coast of South Wales, and later I also got to know and appreciate the North Country through visiting friends.

Family ties have taken me regularly to the West Country, Hawaii and Vancouver. I visited Venice briefly at the end of my student days and always vowed I would go back as it is a Mecca for all artists. There are many reasons for sketching, not only for making a record of travels, but as a store of visual images for future reference, to find inspiration for paintings, or just for sheer enjoyment.

Looking through my sketchbooks often motivates and inspires me to paint; for the painter, all ideas stem from something seen.

MATERIALS

Throughout the book you will find sketches using a variety of media, but most of my sketches are simple pen and ink line drawings without shading, which gives me a freedom of interpretation when it comes to producing a painting later. The 'pen and ink' referred to is a waterproof and lightfast drawing pen rather than a dip pen. Dip pens give a more sensitive line, but carrying a bottle of ink, especially in luggage, has its hazards. Pen drawing is very direct, and does need some bravado, but the spontaneity of flowing lines – even the odd blot – gives vitality to a drawing.

I have listed below the materials that I found most useful during my travels, but there is no restriction on sketching materials so personal preferences will come into your own selection. It is important that you settle for what suits you best, but do not hesitate to experiment occasionally with mixed media. Each medium has its own characteristics, which you will discover as you sketch.

Blaina
Gwent

PENCIL
There are many grades from hard to soft. I usually use 2B and 6B, the latter being the softest.

CHARCOAL
A soft medium giving a sensitive line. Good for tonal effects but will smudge, so it needs a fixative spray or a protective sheet of paper in order to prevent offsetting.

CHARCOAL PENCIL
Charcoal in a compressed form. It is a little harder than the sticks, and not so messy, but will also smudge.

CONTÉ PENCIL
A proprietary name for black, brown, sanguine or white chalk in a hardened form.

PASTEL PENCIL
Pastel in a hardened form, obtained in a variety of colours.

PEN AND INK
Waterproof and lightfast drawing pens are easy to use and are obtainable in a variety of point sizes.

DIP PEN AND BOTTLED INK
The flexibility of the nib gives a sensitive line.

FIBRE TIP AND FELT PENS
Available in a variety of colours. Often not lightfast, and some will bleed through the paper, but very useful for colour notes.

WATERCOLOUR TUBES OR PANS
I recommend that you buy artists' quality; it is worth it.

WATERCOLOUR PENCILS
Good in combination with watercolour, and can give a pleasing diffused quality to the line.

RETRACTABLE BLADE
For sharpening pencils.

BULLDOG CLIPS
Useful to control sketchbook pages in a wind.

SKETCHBOOKS
There are many types to choose from, in many sizes. Sketchpads are obtainable in good quality cartridge paper, watercolour paper or toned paper. When choosing the size, bear in mind the scale of the subject; for quick small-scale sketches and notes a pocket size is ideal.

MISCELLANEOUS:
- **KITCHEN TOWEL** for mopping up spills or seagull surprises!

- **A WATERPROOF SHEET** to sit on for difficult locations, or a cushion in a polythene bag (very useful when perched on top of a wall!)

- **A HAT**

- **INSECT REPELLENT AND SUN SCREEN LOTION**

- For hot countries I take a **WHITE UMBRELLA** which I lean against my shoulder and whose handle I hook on to my sketching stool. A little awkward, but effective so long as it isn't windy.

- Finally, a word of caution: do not expect to find art shops on your travels, so make sure you have enough equipment with you.

TRAVELLING BY AIR

Before any journey my first decisions about what to pack relate to the all-important sketching equipment! On my last family visit to Hawaii and Vancouver I took the minimum, comprising a thick 19 x 24cm (8 x 10in) hardback sketchbook, a very old metal cigarette tin (10 x 7cm/4 x 3in) jammed with pans of artists' quality watercolours, plus a few tubes of watercolour and a plastic palette with paint already squeezed out. The latter I secured in a strong polythene bag. My water pot was a health pill container 10cm (4in) tall with a tight-fitting lid, inside which I put the tubes of paint and a blade for sharpening pencils. It is essential to pack the blade in your case rather than your hand luggage for security reasons. Waterproof black ink pens in various point sizes, a few watercolour pencils and felt pens, one 6B and one 2B lead pencil, and a fine Conté pencil completed the sketching equipment. I also packed a small haversack, big enough to hold everything. For the journey I put one of the drawing pens, plus two or three felt pens, in my handbag and the sketchbook in a polythene carrier bag, to be handy at a moment's notice for any sketching opportunity. I always keep my folding stool with me as hand luggage, useful not only for sketching but as a seat when waiting in the inevitable queue at an airport or station. I do not take fixative when travelling by air; I prefer to take a few sheets of cheap paper that I can place between pages to prevent smudging, then fix the work when I return home.

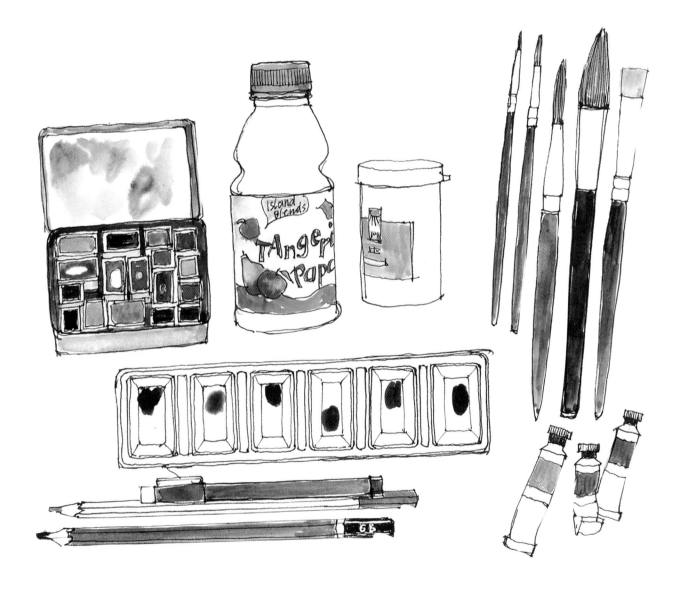

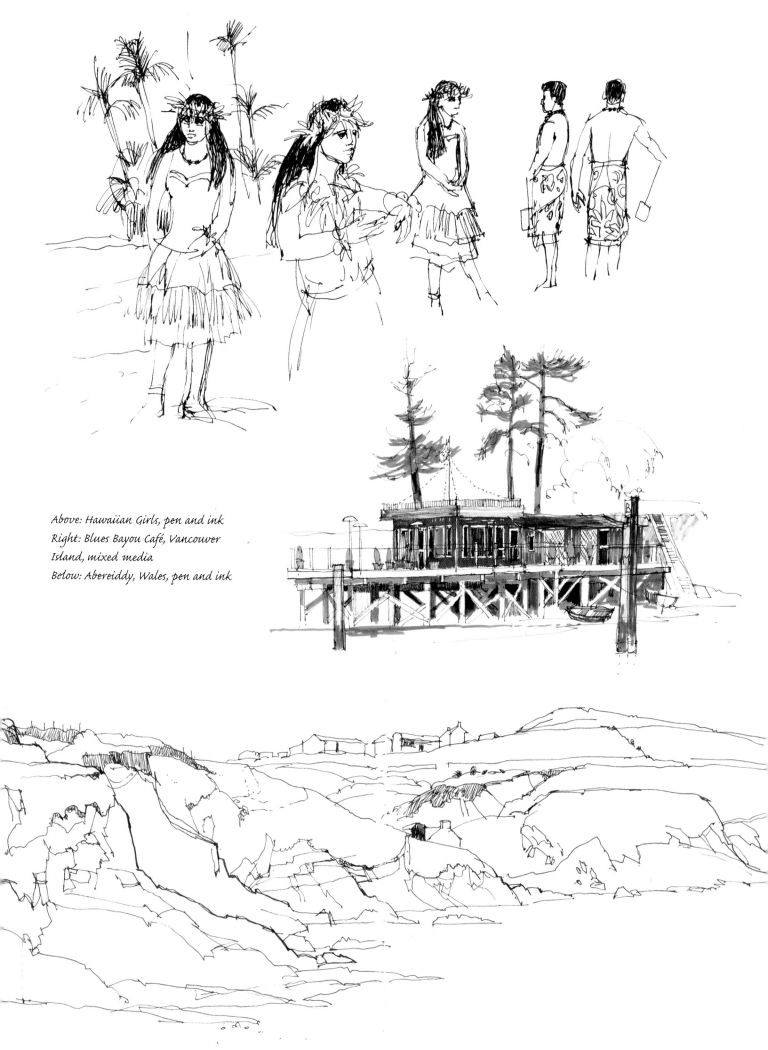

Above: Hawaiian Girls, pen and ink
Right: Blues Bayou Café, Vancouver
Island, mixed media
Below: Abereiddy, Wales, pen and ink

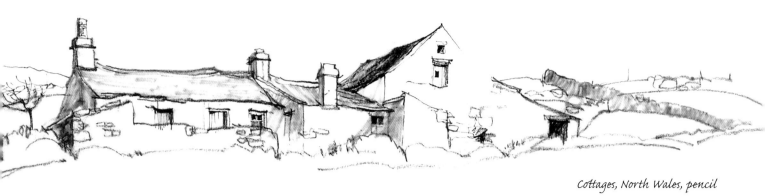

Cottages, North Wales, pencil

HINTS ON OBSERVATION

Select a point of view and analyse what appealed to you in the first place, perhaps the skyline or a particular building or a group of trees or figures.

If your view is awkward, such as one item exactly in line with another, then temporarily move your position slightly to one side to resolve the problem. Before you start, try to make sure that the view selected will fit on the paper. Don't rub out mistakes – you will probably repeat them, so make alterations by drawing over the top. Be practical when sketching, plan the day so that you can limit the amount of equipment and only carry what is necessary rather than overload yourself.

PERSPECTIVE

We observe and make marks that create three dimensions on a two-dimensional piece of paper, so a little knowledge of perspective is helpful. Put simply, everything you observe relates to your own eye level; this is your horizon line. Objects taller than you will have lines that slope down to your horizon line, and all objects that are smaller than you will have lines sloping up to your horizon line. Objects on your eye level will remain in a straight line. I also use verticals and horizontals as a reference.

FIGURES

People are fascinating to draw. Try to capture the general stance and relate them to their surroundings. Concentration can be intense when looking hard and sketching quickly, because figures tend to move on, so leave details until later. When sketching a working group I often start drawing more than one figure and wait for a repetition of movement. In my drawing of O'Neill's bar at Heathrow I had to adapt to a changing clientèle!

BUILDINGS

When judging proportions, try to measure by eye the relationship of one part of the subject to another, for instance, the height of a doorway compared to the height of the building, or the width of the doorway compared to an adjoining window. You can check proportions by holding a pencil at arm's length, keeping it vertical and closing one eye, then slide the thumb up and down the pencil to judge the measurement. Relate figures to the height of windows and doors. Details such as window panes can show a play of light and shade; reflections will vary the tones.

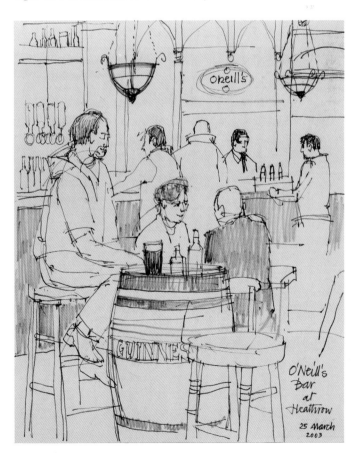

O'Neills' Bar, Heathrow, England, pen and ink, 2B pencil and felt pen

HAWAII, USA

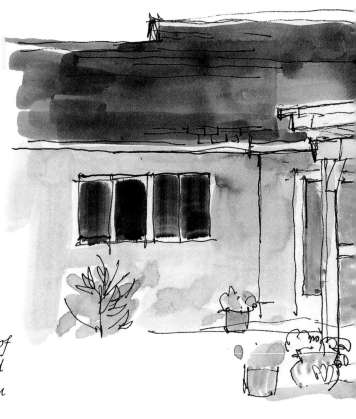

I am lucky to have a daughter living on the island of Maui, one of the most beautiful of the Hawaiian group of islands. This gives me the opportunity to travel afar and see an abundance of flora and fauna very different from the British Isles.

It is awesome to see familiar houseplants growing freely on a grand scale out in the open air of this subtropical island, and to see the abundance of colourful fish that swim at the ocean's edge.

On this long-haul trip, sketching equipment was minimal, as you will see illustrated on page 7. I also carry insect repellent, a sun hat and a sketching stool. The latter is also useful when waiting in airports. It was after midnight when the flight touched down at Kahului airport in the midst of a tropical rainstorm, and on the way to the carousel I had to negotiate rows of bright red buckets strategically placed to catch the roof leaks caused by the heavy storm!

Next morning it was warm and sunny and I lost no time in exploring my new surroundings and making a few sketches of the exotic plants, growing outside the bedroom window. I drew the front gate flanked by lush

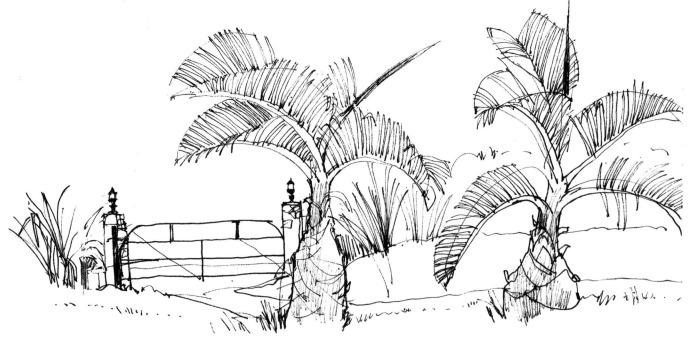

Front gate, pen and ink

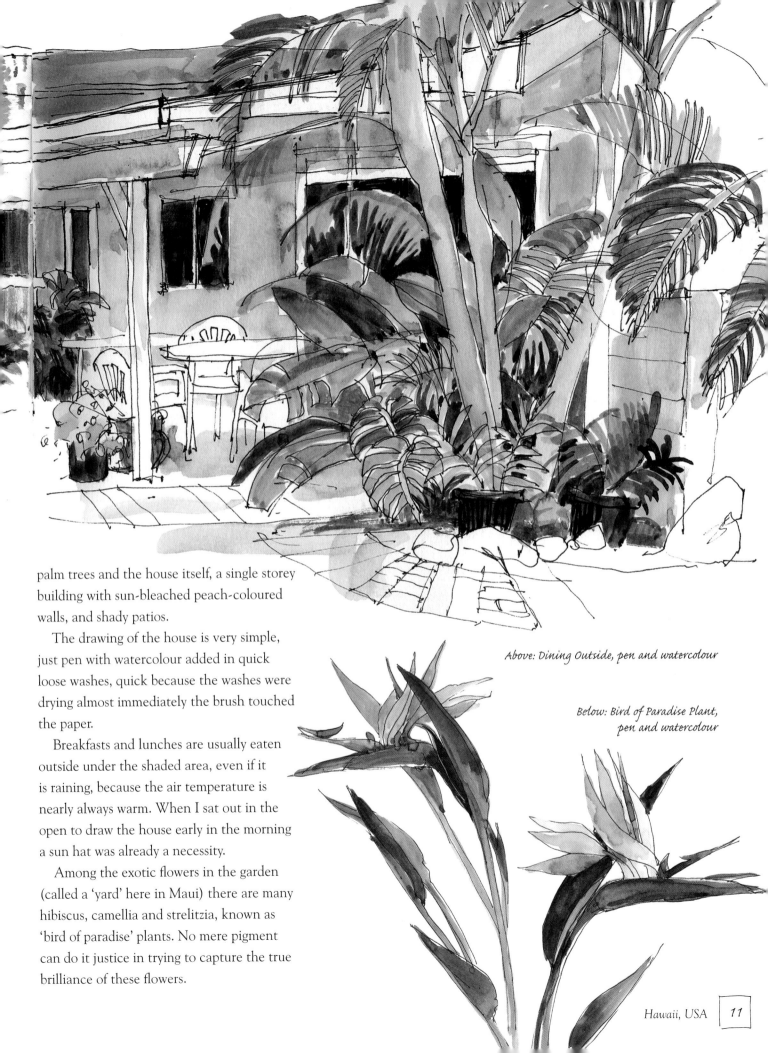

palm trees and the house itself, a single storey building with sun-bleached peach-coloured walls, and shady patios.

The drawing of the house is very simple, just pen with watercolour added in quick loose washes, quick because the washes were drying almost immediately the brush touched the paper.

Breakfasts and lunches are usually eaten outside under the shaded area, even if it is raining, because the air temperature is nearly always warm. When I sat out in the open to draw the house early in the morning a sun hat was already a necessity.

Among the exotic flowers in the garden (called a 'yard' here in Maui) there are many hibiscus, camellia and strelitzia, known as 'bird of paradise' plants. No mere pigment can do it justice in trying to capture the true brilliance of these flowers.

Above: Dining Outside, pen and watercolour

Below: Bird of Paradise Plant, pen and watercolour

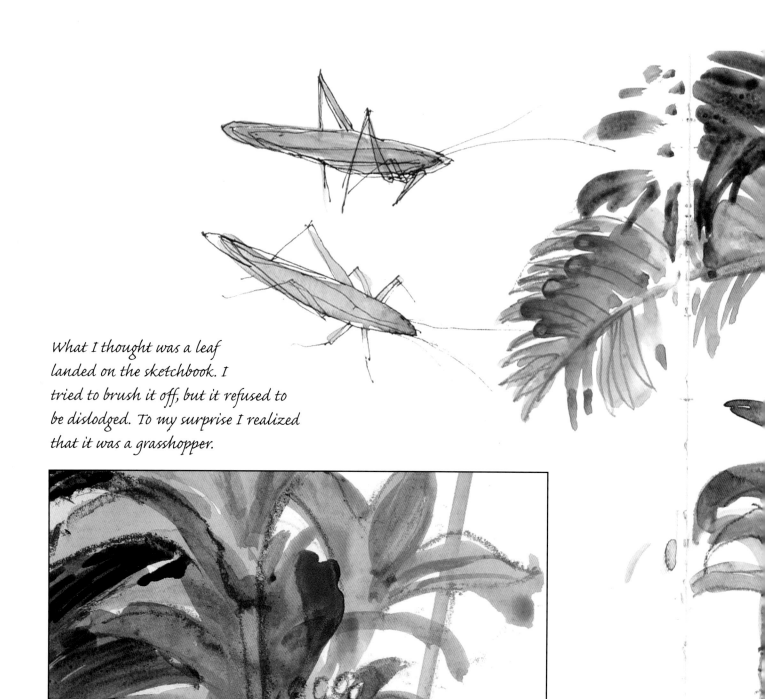

What I thought was a leaf landed on the sketchbook. I tried to brush it off, but it refused to be dislodged. To my surprise I realized that it was a grasshopper.

Palm and Ti Plants,
watercolour and watercolour pencil

Palm and Ti plants

These subtropical plants are fascinating to draw and paint and I wanted to capture their brilliance. Transparent watercolour is at its most effective on white paper as light will reflect through the pigment; however, white paper is dazzling in full sunlight, so I hastened to cover the surface with loose watercolour washes applied with a large brush.

I used very little water in order to maximize the intensity of the watercolour pigment, but even so, nothing can be as brilliant as the actual plants. My efforts to achieve some of the exotic colour and lush growth must have been reasonably successful because what I thought was a leaf landed on the sketchbook. I tried to brush it

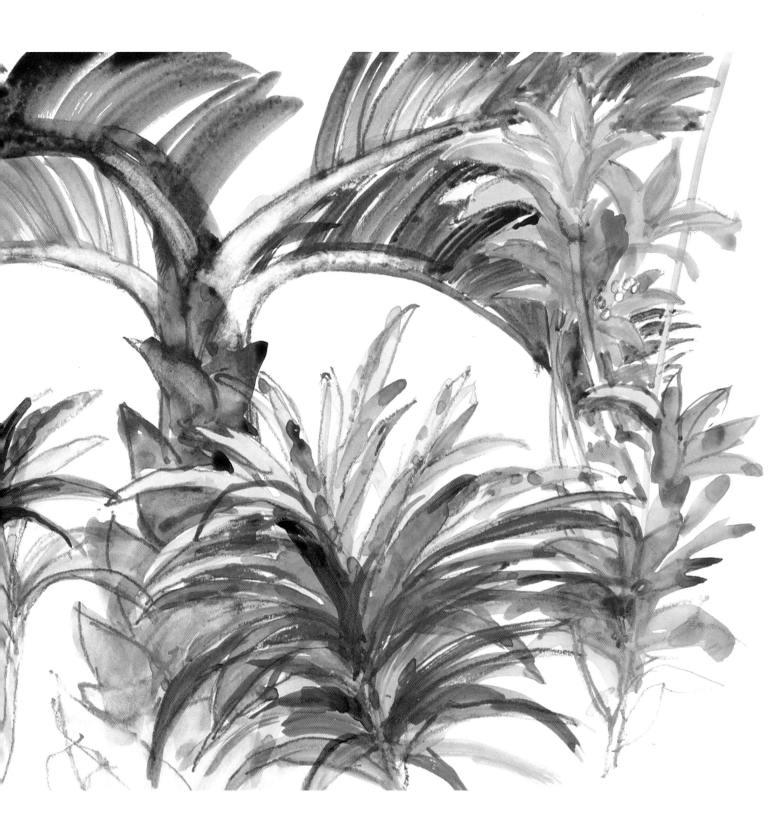

off, but it refused to be dislodged. I realized that it was some kind of grasshopper. Maybe it thought my rendering was a real plant! It stayed long enough for me to sketch it life size, in fact it remained attached to the page long after I had finished the watercolour and I had to blow it off eventually.

Drawing over watercolour washes with watercolour pencils can give a pleasantly diffused quality of line. Here I have used different colours to add vibrancy.

Sometimes I dip the tip of the watercolour pencil into the water pot before drawing, which keeps the line soft where the washes have dried fast in the sun.

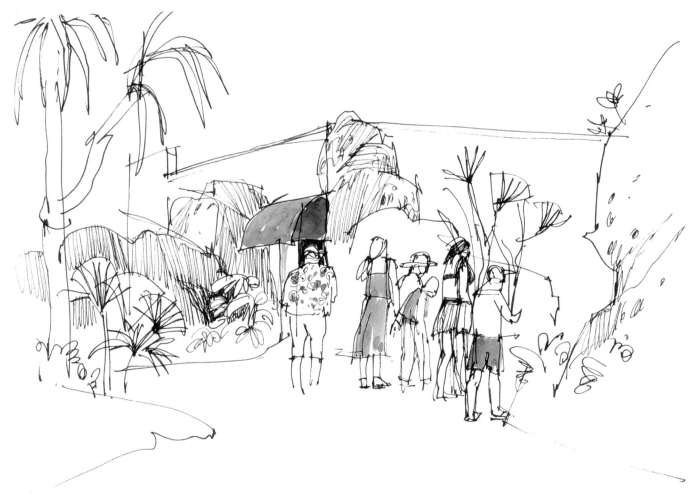

Visitor centres provide wonderful opportunities for sketching interesting people from all over the world. Here at the Maui Ocean Centre in Ma'alaea I could have stayed all day observing many types, but as usual on a family holiday, sketching time is limited. This is no bad thing because sketching at speed can sharpen the vision and give a freedom to the line.

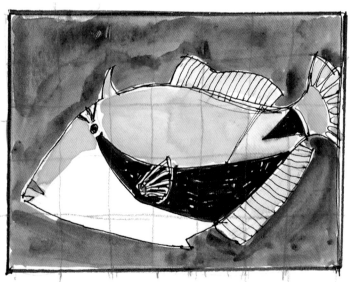

Entrance to the Maui Ocean Centre, Ma'alaea

▲ I spent a long time at the centre. The variety of fish on show in the aquariums was amazing, very colourful and strange, almost science fiction in shape. The largest tank held seven stingrays and lots of young sharks up to seven feet long. I watched two divers feeding the fish; one stingray took clams from the hand of a diver, just like a puppy, and kept coming back for more. Within the tank there is a walk-through tunnel, which gives you the weird feeling of being in the tank amongst the fish – close encounters! Unfortunately it was too dark and crowded to be able to sketch indoors. *Pen and ink*

Washroom Tiles

◄ The ladies' washroom at the Ocean Centre provided an interesting subject: I found a marvellous tiled wall decoration. Everyone wondered why I was gone so long, but I just had to sketch it and make colour notes to paint later! The design based on a fish was so decorative. *Pen, ink and watercolour*

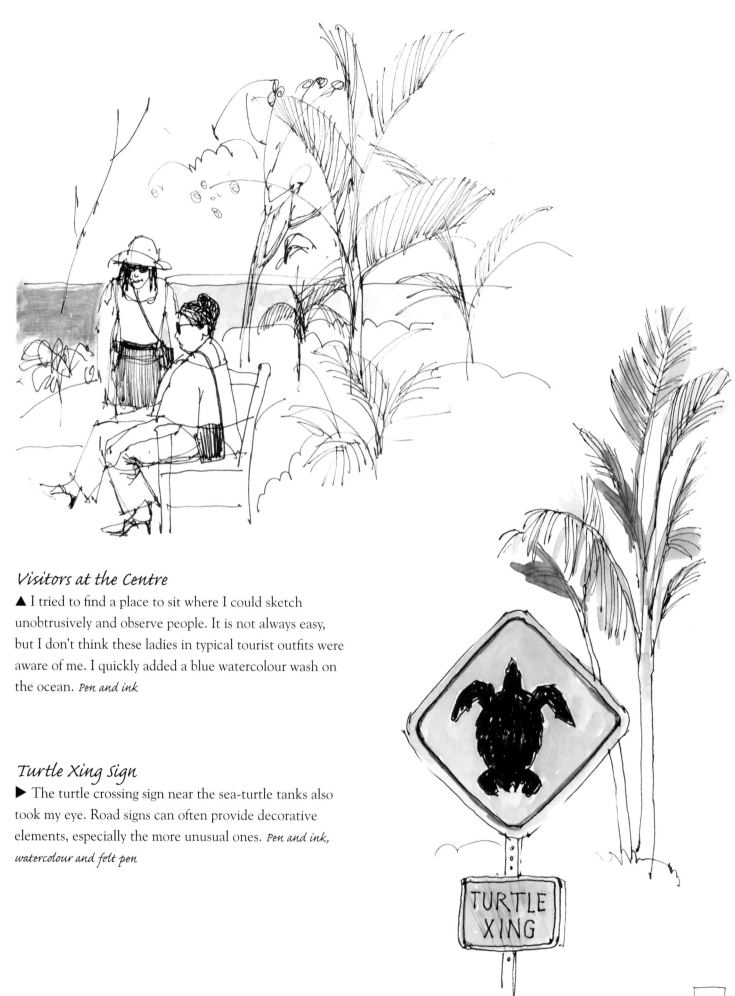

Visitors at the Centre

▲ I tried to find a place to sit where I could sketch unobtrusively and observe people. It is not always easy, but I don't think these ladies in typical tourist outfits were aware of me. I quickly added a blue watercolour wash on the ocean. *Pen and ink*

Turtle Xing Sign

▶ The turtle crossing sign near the sea-turtle tanks also took my eye. Road signs can often provide decorative elements, especially the more unusual ones. *Pen and ink, watercolour and felt pen*

TURTLE XING

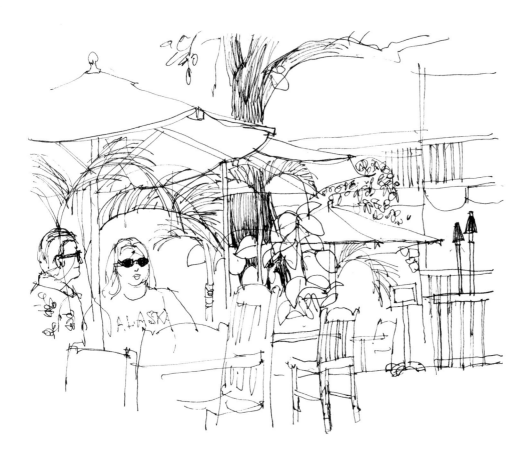

The highway to the west coast of Maui crosses the island and is bordered by vast fields of sugar cane, growing eight to ten feet tall. There are special crossing points for gigantic trucks to transport the heavy loads of cane. Along this coast is the historic town of Lahaina, originally an old whaling port. Here I found many subjects to draw – boats in the harbour, unusual shops and signs, cafés and lush growth everywhere.

Kimo's, Lahaina

▲ It was a very hot day and it was a relief to stop at an ocean-front restaurant for a very British cup of tea. Decorative plants and interesting people make sketching in the island's cafés rewarding. I try not to embarrass people while they are eating, and pretend to be drawing something else until they look away, then I rapidly sketch in a few lines. This process often needs to be repeated several times until I have enough information.

On this particularly hot day I was amused that the lady opposite was wearing a T-shirt that said 'Alaska'. *Pen and ink*

▼ Kimos Café, Lahaina

This was painted many months after I had returned from Hawaii, but I could recall the mood of the day when I looked at the sketch. I loved being able to eat out under colourful umbrellas and being surrounded by the lush growth of subtropical plants.

Watercolour and gouache, 21 x 26cm (9 x 11in)

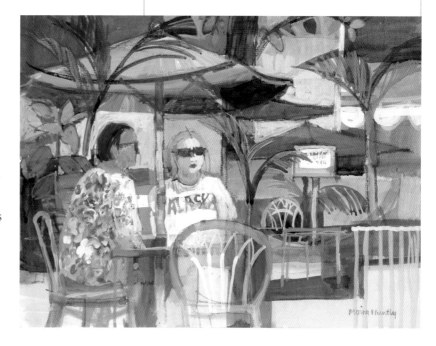

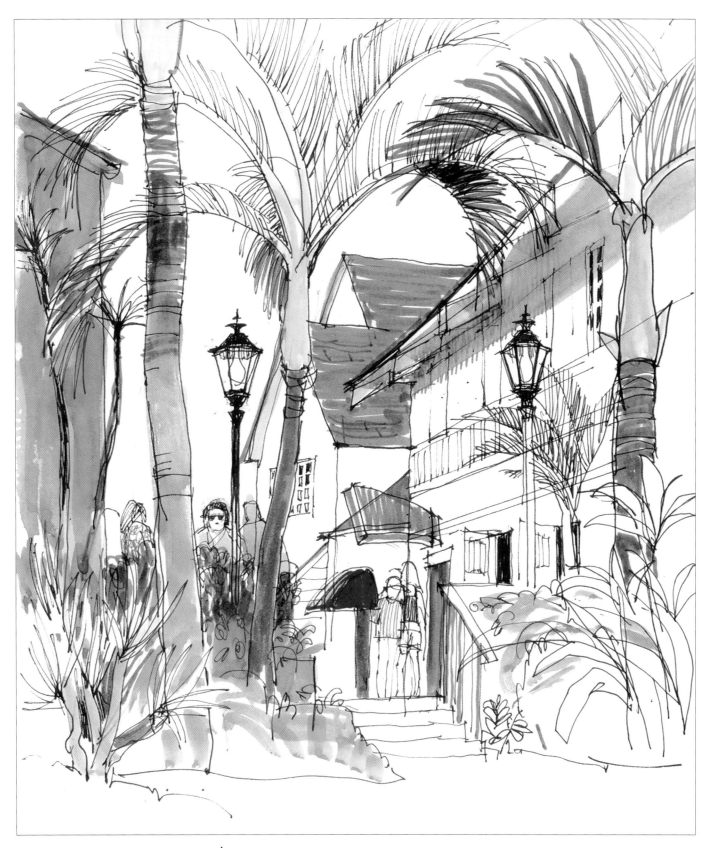

Five O Five, Front Street, Lahaina

▲ This is one of many interesting streets in this town that end on the ocean front. I chose a place on the beach that was in the shade of a palm tree and tried to keep my sketching stool level on the soft sand. My back was to the ocean but there was no risk of the tide coming in on this occasion. I have used watercolour to add a few colour notes and some tone on the buildings to create a feeling of strong sunlight. *Pen, ink and watercolour*

I drove upcountry to visit the enchanting floral gardens on the lower slopes of Haleakala, an extinct volcano. The gardens were at 2,500ft and I found them delightfully cool. Exotic plants and flowers were in abundance: proteas, hibiscus, orchids and various palms. The succulents were unbelievably large, and some were as tall as my house back home. I stopped to draw the protea plant, a complex subject, but I suffered for my art, as the mosquitoes had a feast and the effects of the bites were to last several days! Lesson – use insect repellent even at higher altitudes.

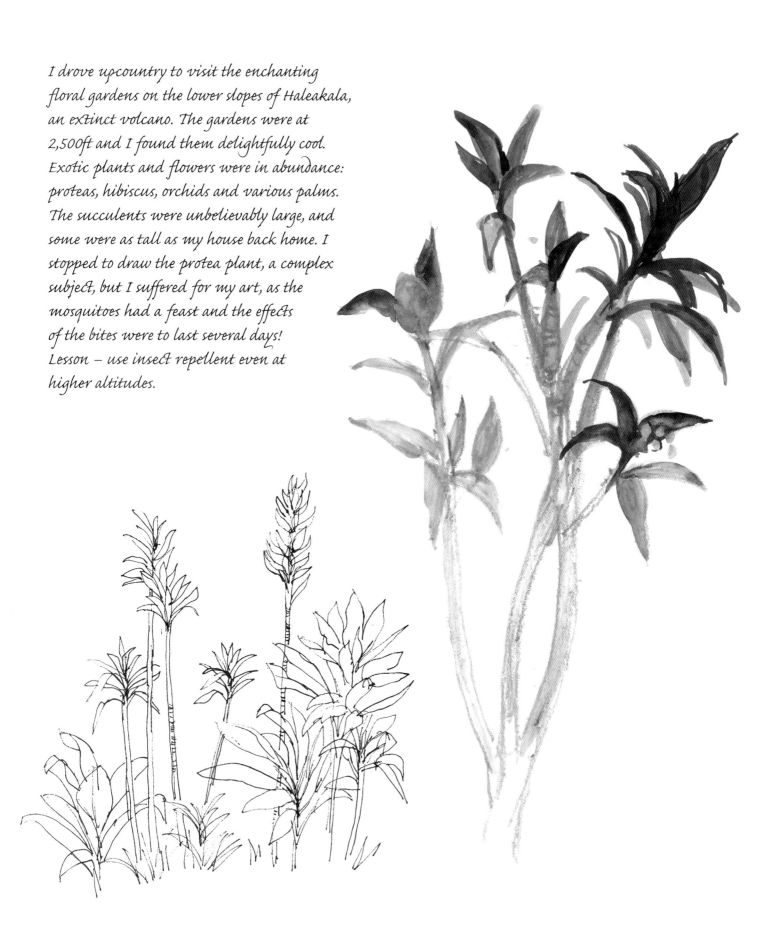

Above: More Ti Plants, pen and ink

Above: Ti Plant, watercolour and watercolour pencil

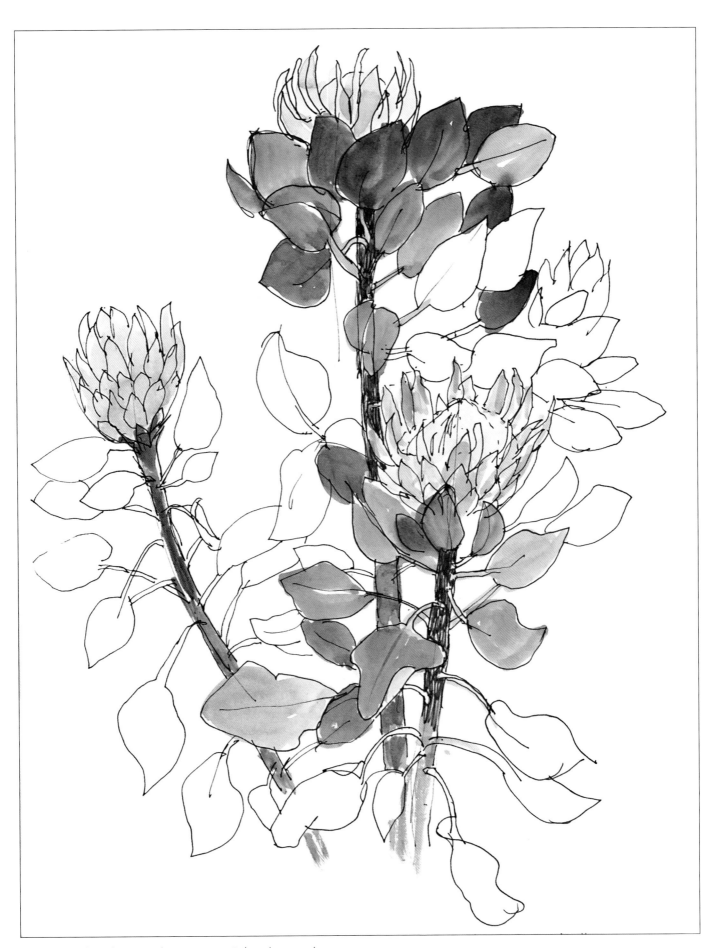

Proteas, Floral Gardens at Kula, Maui, pen, ink and watercolour

The Queen Ka'ahumanu Centre is a vast air-conditioned shopping mall on the outskirts of Kahului, with indoor palms and a band playing popular American 'standards' while shoppers amble by. I found it an ideal place for sketching in comfort; no mosquitoes or extreme heat to deal with and plenty of vantage points. Also, people are so busy looking in shop windows they don't notice anyone sketching.

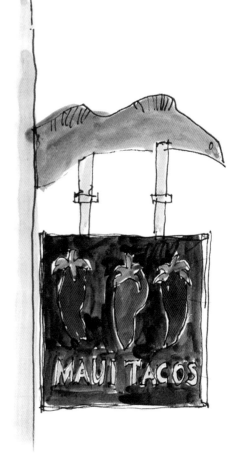

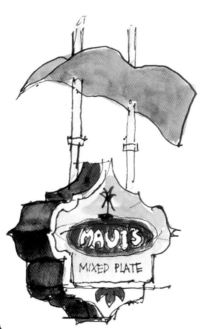

Signs at the Queen Ka'ahumanu Centre
▲ Whilst waiting for lunch to arrive I drew the signs hanging from above. *Pen, ink and watercolour*

◄ This sign amused me, seen outside a shop in Paia on the Hana Highway. Paia is a hippy town on the north shore, full of surfers who ride the big waves. The town is surrounded by cane fields and has many interesting shops, many with old wooden fronts, some brightly coloured. The drawing will be added to my fund of decorative references for future potential paintings. *Pen, ink and watercolour*

Sweet and Bubble Gum Machines

▼ I even found something to draw outside the Safeway store in Kahului while the family were shopping. Typical of kids everywhere, this boy is wearing baggy shorts and a cap back to front. *Pen, ink and watercolour*

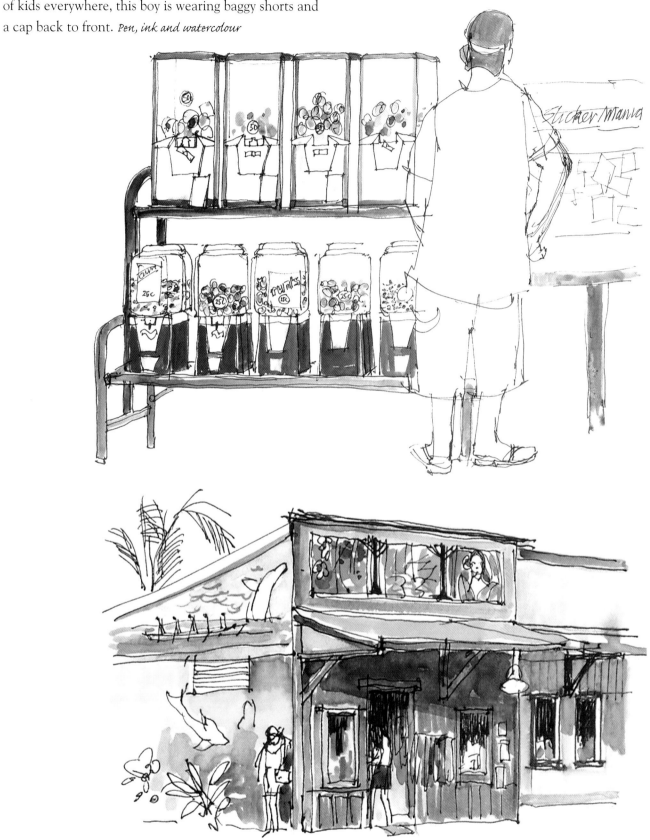

Shop Front, Paia, pen, ink and watercolour

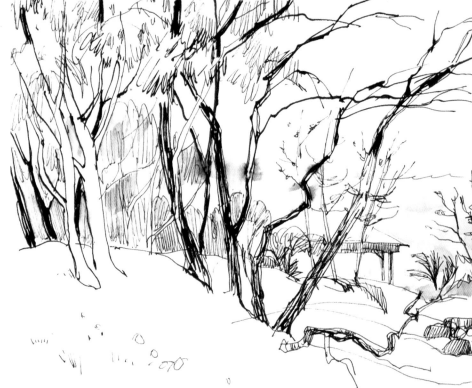

Line and wash is a popular combination of media; the contrast between a decisive pen line and a simple watercolour wash is very effective. Felt-tip pens are not always waterproof and where I have used them on tree trunks it has run and bled into the wash, sometimes with quite pleasing effects.

Spreckelsville Beach

▲ This beach is one of the windiest on the north shore, making it ideal for kites and wind surfing. It was difficult to sketch that day, because it was hot and a strong wind caused the sand to swirl and sting against the skin. Having to draw at speed helped to suggest a windy day. In the background are the West Maui Mountains. *Pen, ink, felt-tip pen and watercolour*

▶ Here is a scene of relaxing on the beach after a whale-watching trip. This is a typical west shore beach with water's edge buildings and palm trees bending towards the Pacific Ocean. *Pen and ink*

Driftwood

▼ Walking along the north shoreline at Baldwin Beach I came across many pieces of driftwood, some quite large. I love the texture and abstract quality of their twisted forms. *2B and 6B Pencil*

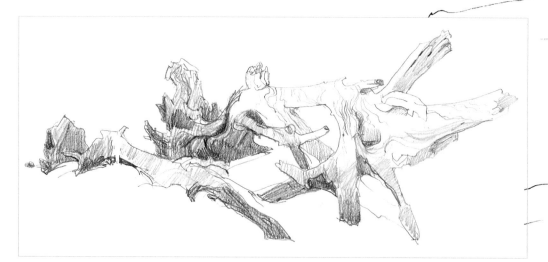

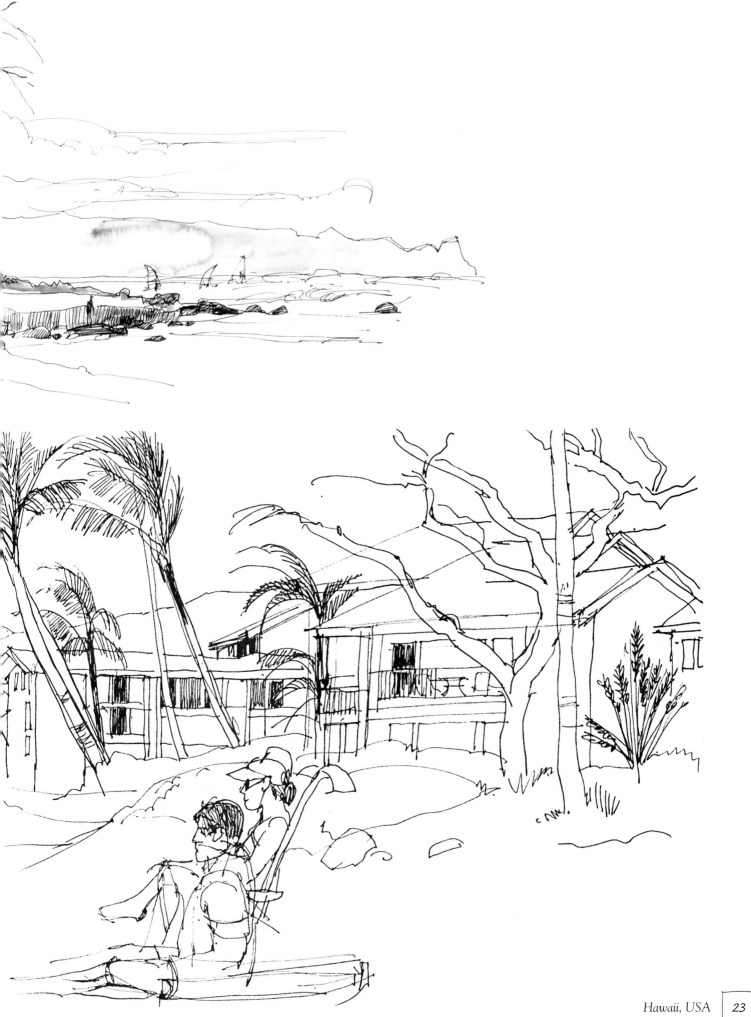

Wailea (meaning 'water belonging to Lea', the
Hawaiian goddess of canoe making) is located on
the southeast coast of Maui and was once a brush
and cactus desert until water became available in
the 1970s. Today it is a popular resort.

Wailea

▲ This elegant house by the ocean is fronted by tall
palms and unusual trees. The combination of tree forms
against the building provides good design, texture and
pattern elements to inspire an interesting future painting.
I made a few quick colour notes of the exotic plants in
the foreground. *Pen, ink and felt-tip pen*

Ma'alaea Shopping Centre

▶ Another quick sketch of an interesting tree form with
large blooms, against a background of buildings. The shop
fronts are individual in design; in particular I liked the
wording of the cake shop advert. *Pen and ink*

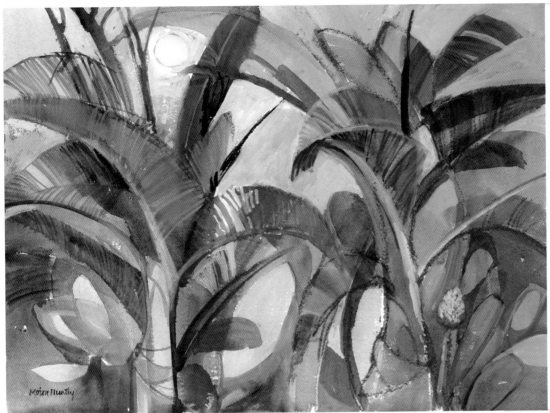

Evening, Hawaii

◀ This interpretation of some of the plant forms I have sketched has become rather romanticized with the introduction of subdued evening light and a yellow moon. Blues and greens predominate, representing the lush growth to be seen everywhere in this subtropical part of the world. *Watercolour and gouache, 26 x 36cm (11 x 15in)*

Moira Huntly

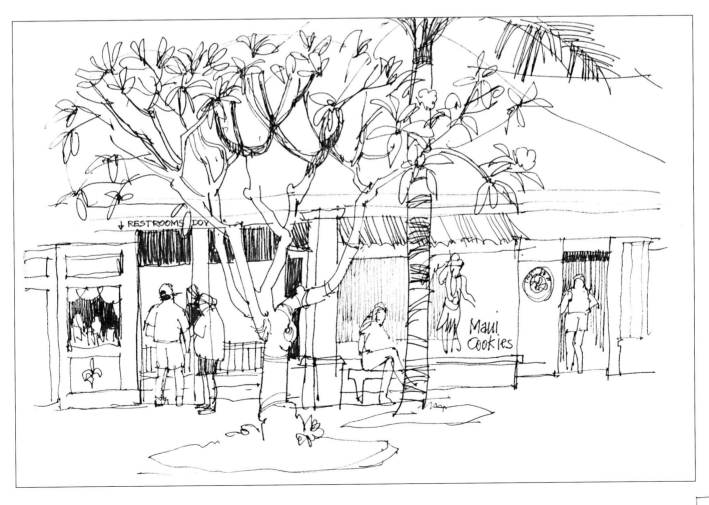

↓ RESTROOMS DOV

Maui Cookies

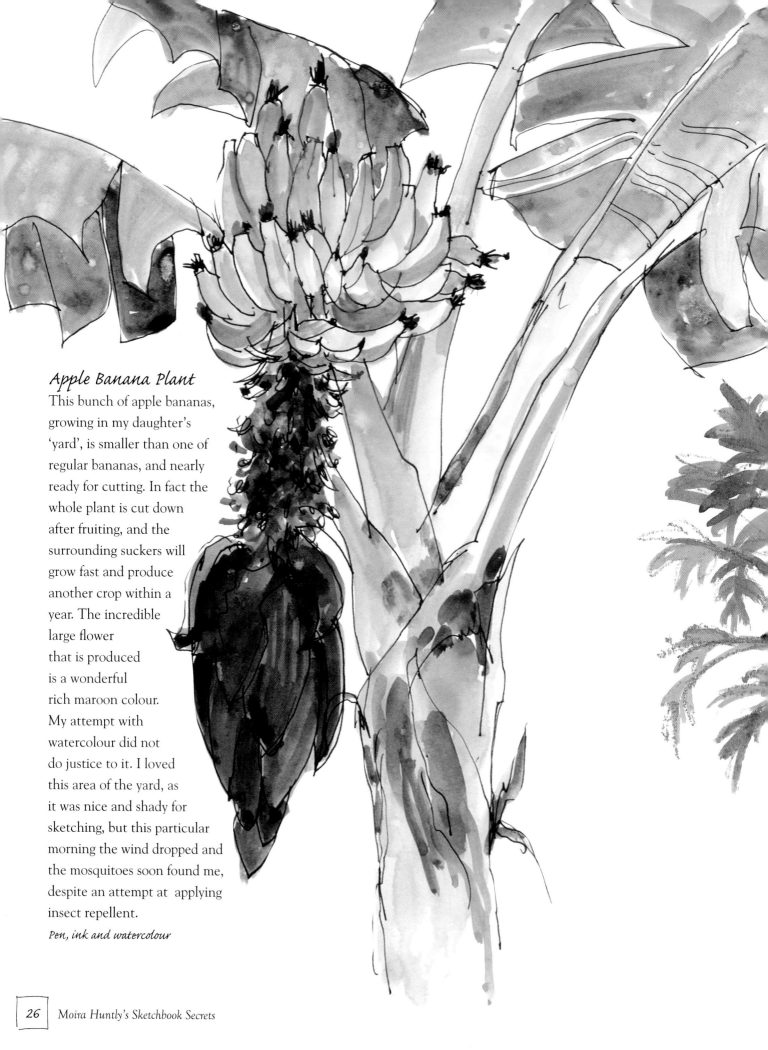

Apple Banana Plant

This bunch of apple bananas, growing in my daughter's 'yard', is smaller than one of regular bananas, and nearly ready for cutting. In fact the whole plant is cut down after fruiting, and the surrounding suckers will grow fast and produce another crop within a year. The incredible large flower that is produced is a wonderful rich maroon colour. My attempt with watercolour did not do justice to it. I loved this area of the yard, as it was nice and shady for sketching, but this particular morning the wind dropped and the mosquitoes soon found me, despite an attempt at applying insect repellent.

Pen, ink and watercolour

Papaya Fruit

▼ From a distance I thought that this plant must have been a coconut tree, but I soon realized that the lush growth of leaves were shading an equally lush growth of papaya fruits. This made the most decorative of subjects. *Watercolour and watercolour pencil*

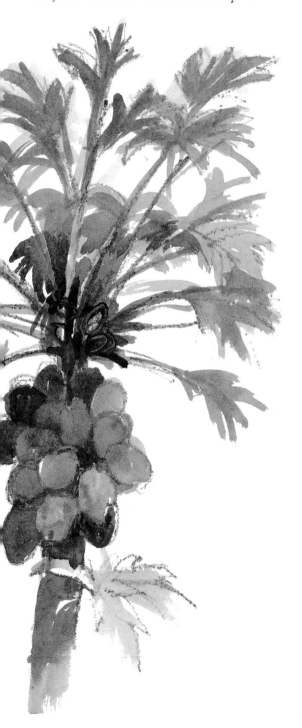

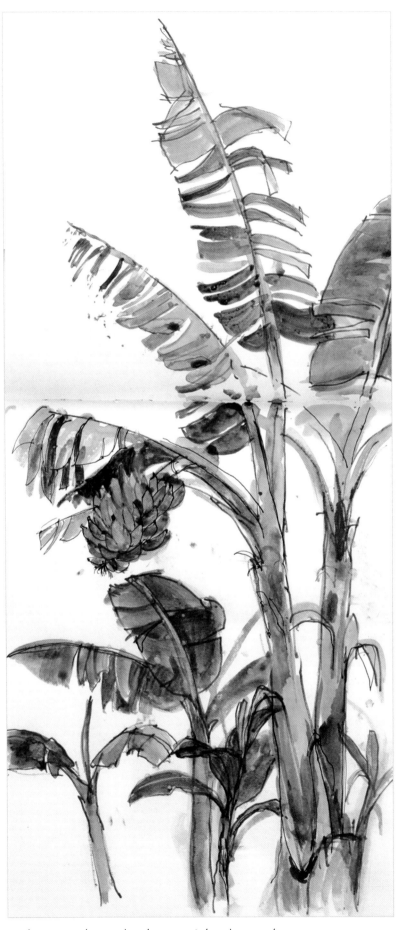

Apple Banana Plant and Suckers, pen, ink and watercolour

WEST COUNTRY, UK

This is one of my favourite sketching places and it offers a wealth of subject matter. Sadly the number of fishing boats to be found in and around coastal villages in Britain today is diminishing.

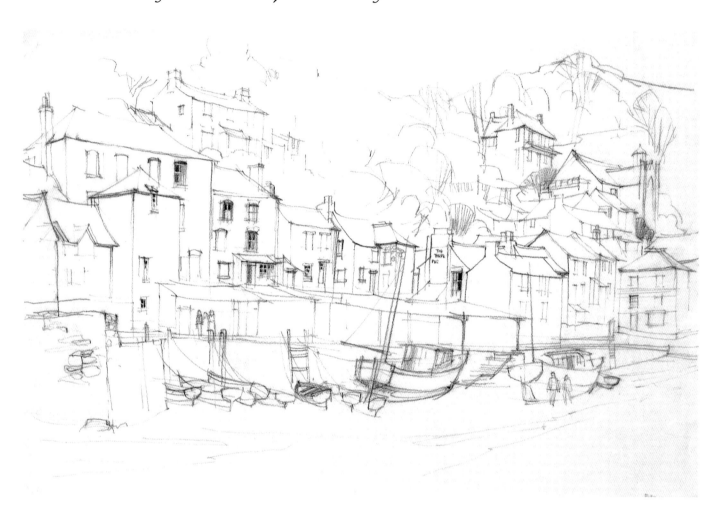

Polperro, Cornwall

▲ In this sketch I tried to capture the feeling of an enclosed sheltered harbour with its jumble of different sized and shaped buildings and types of boat surrounding the fish-market sheds on the quay. A large drawing such as this takes time, and on a bright sunny day, if you are sensitive to bright light, the reflective glare from the surface of white paper can be troublesome to the eyes. You can cut the glare considerably by using a toned paper.

The starting point for the drawing was the building that initially attracted me to the subject, and that was the unusually tall house towards the left, and the group of dinghies tied up to the harbour wall. The drawing gradually expanded along the row of quayside houses. I incorporated a few figures as they appeared, and added the washing on the line to give some life to the subject.
Charcoal pencil on toned pastel paper

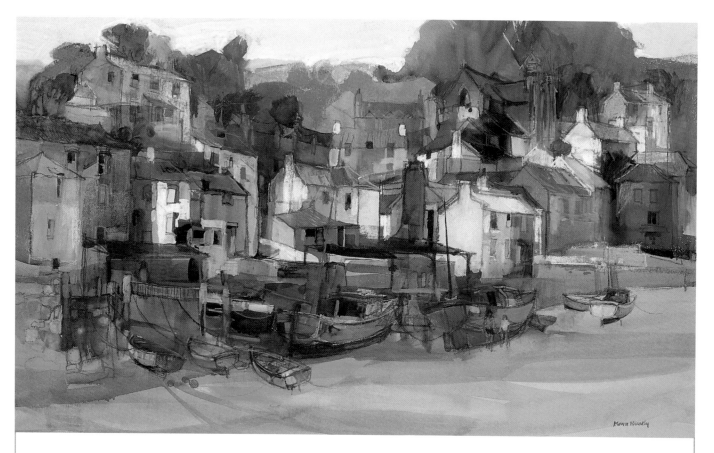

Polperro, Cornwall

▲ A limited palette gives a feeling of unity to this painting. I mainly used ultramarine blue, raw sienna, burnt sienna and white gouache, intensifying these colours on parts of the foreground boats and buildings. My aim was to capture the atmosphere of fleeting light catching the ends of buildings. Cool blue washes in the background also help to create that atmosphere and act as a foil to light areas and warm colours on the buildings. The church on the hillside blends in unobtrusively with the colour and tone of the trees, and the dilute washes of ultramarine blue over the raw sienna on the foreground create subtle shadows on the sand. *Mixed media, 45 x 73cm (18 x 29in)*

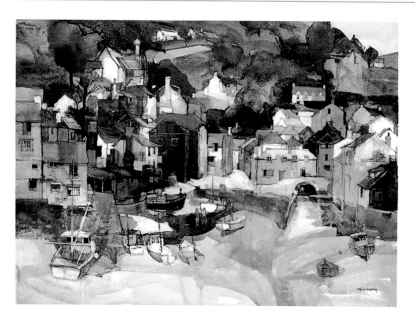

Polperro, Cornwall II

◀ Another view of Polperro's delightful jumble of buildings and boats at low water. Warm washes of raw sienna, cadmium orange and touches of white gouache contrast against deep ultramarine blue, Payne's grey and burnt umber to produce an impression of a sunny day. *Watercolour, 55 x 72cm (22 x 29in)*

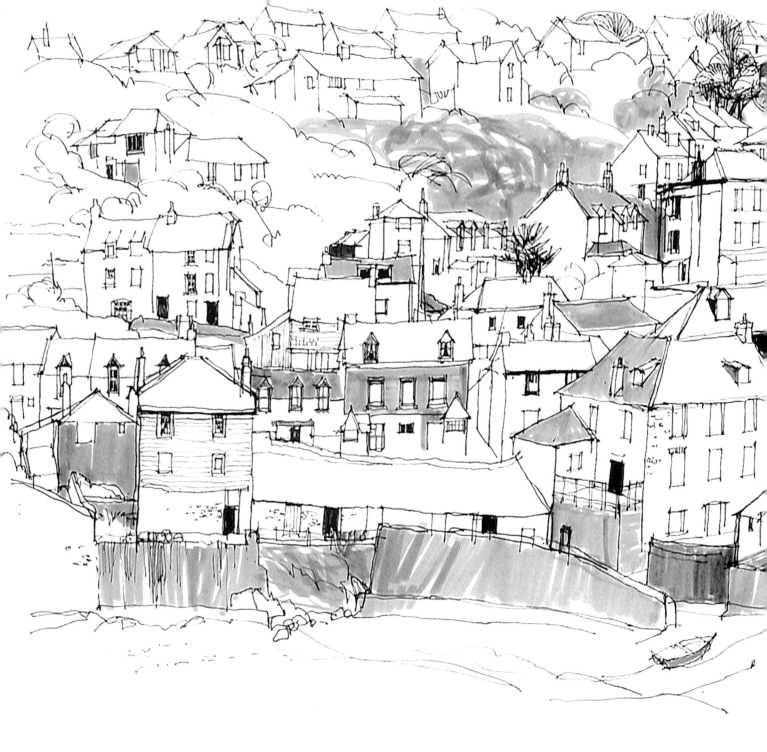

Port Isaac

I really enjoyed staying in Port Isaac with its colourful houses, steep and narrow streets and its sheltered bay harbour. I also enjoy the challenge of drawing a jumble of rooftops, different sizes and shapes of buildings, windows and chimneys. Having confidence to draw directly with a pen, no preliminary pencil, and no rubbing out, comes with practice and keen observation. I don't worry about altering a line, I simply draw over the top of it and the original line becomes absorbed into the drawing as it progresses. When the subject is complex and wide ranging, I am often asked where I started. Firstly, I look at the subject and decide how much I want to include, and this may then involve the selection of a double-page spread. Then I start drawing the part of the subject that attracts me most, which in this case was the long foreground building and harbour wall where the fishermen hang their nets. Once that area was established as the starting point, every other building that I drew was related to it, constantly

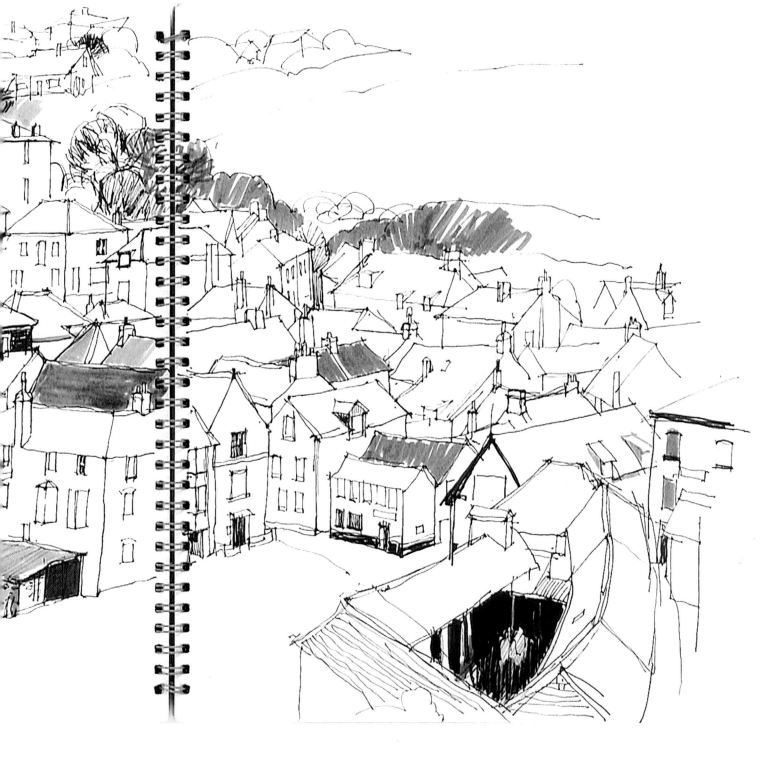

looking above and below and to each side as the drawing progressed, fitting them in rather like a giant jigsaw puzzle. Felt pens are very useful tools for indicating tone and making colour notes, though they may not be lightfast. Here I only had time to add the turquoise-painted windows that had caught my eye. Over the years this drawing has been the inspiration for a number of paintings in different media, sometimes only selecting a part of the drawing as the basis for a painting. *D/S drawing technical pen and felt pen*

I sat on the outer harbour wall with my back to the sea, looking inland towards the lifeboat station. This was a safe position to take up when attempting a complicated drawing that would take time, because there was no need to worry about being engulfed by an incoming tide! Luckily for me, on a number of previous occasions when I have been totally absorbed with a drawing, 'locals' have been kind enough to warn me that the incoming tide can be fast approaching behind my back. I admit to roaring with laughter when I saw it happen to someone else.

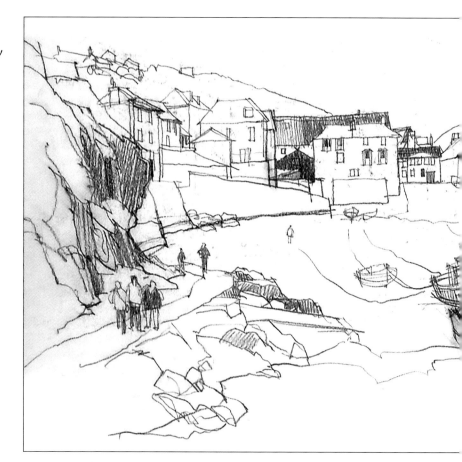

Port Isaac

▲ My starting point for this sketch was the big house directly facing me, having already planned in my mind's eye that I would have enough space to include the rock face on the left and extend the drawing on to the next

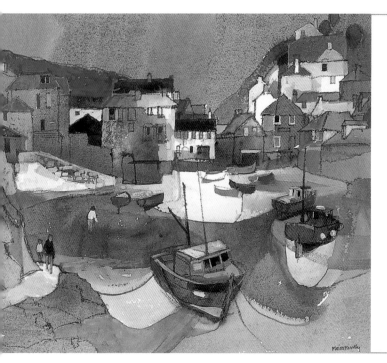

Low Water, Port Isaac

◄ The drawing above inspired this watercolour, picking and choosing parts of the sketch, discarding other parts, and adding other elements, for example, some extra boats. I wanted to capture the impression of a summer day with a deep blue sky, blue hills and shadows, contrasted with warm yellow sand. Much contrast can be gained with the use of a limited palette and the intensification of the strongest light tones with creamy yellows and warm whites placed centrally. This mainly yellow and blue palette was extended with the addition of cadmium orange and burnt sienna.

The painting is an interpretation of the sketch rather than a straight copy. *Watercolour, 34 x 41cm (14 x 17in)*

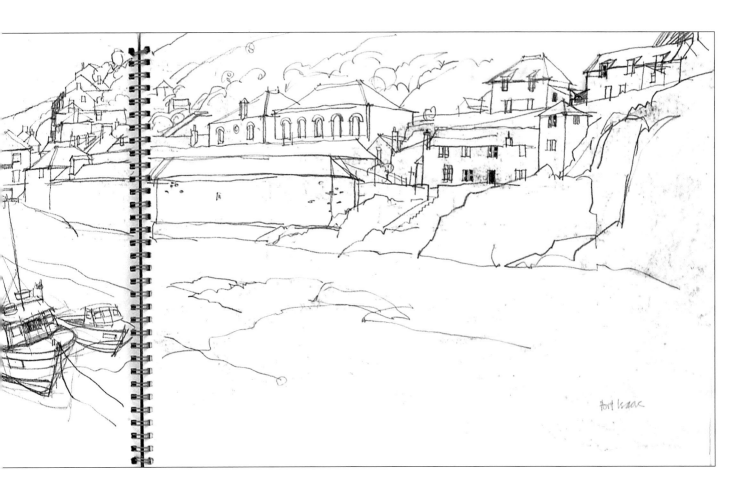

page to allow for the whole sweep of the harbour. It is a good idea when using Conté pencil or charcoal, particularly for a double-page spread drawing, to spray with fixative to prevent the image from being transferred on to the opposite page. I forgot to do this, and so there are a few unintentional smudges, which don't really matter in this instance because I regard this as a working drawing. *Dark grey Conté pencil*

Port Isaac

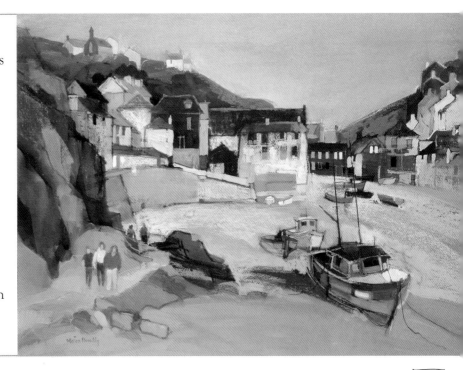

▶ The Conté pencil drawing also inspired this painting, but this time the medium is pastel and the colour emphasis is totally different to the watercolour interpretation. There is a more subtle, airy feeling and the light is soft with a pale sky and light-coloured sand.

Comparing the two paintings, you will see that some parts have been reversed tonally; a central building has a light row of windows on a dark wall as opposed to the watercolour version. Using a black and white sketch for reference allows for a free interpretation when painting. *Pastel, 45 x 59cm (18 x 23in)*

I always have a sketchbook in the car and a drawing pen in my bag to cover all eventualities, so on a journey home from Devon I made a detour to the coast and found Teignmouth.

Teignmouth
▼ With a long journey ahead of me I had little time to spare, so this had to be a quick sketch. This is no bad thing; having to work at speed sharpens the concentration and gives a freedom to the line.
Pen and ink

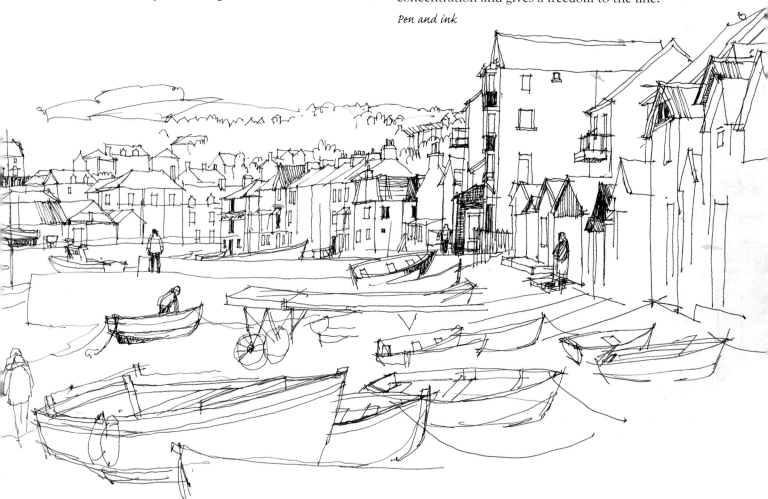

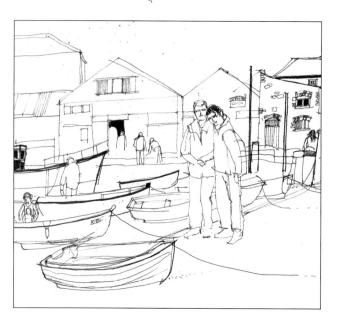

James and Ian at Teignmouth (detail)
◀ This is another drawing of Teignmouth, made a few years later. I had always intended to return to this place with its buildings by the water's edge, beach huts and warehouses and people pottering about with their boats. As I was sketching, a group of teenagers approached and, typically, two of them stood in front of me and said, 'Would you put us in your picture Miss?' I surprised them by saying yes, on condition that they stood still for a few minutes. They then surprised me in turn by doing so, hence the title of the sketch. *Pen and ink*

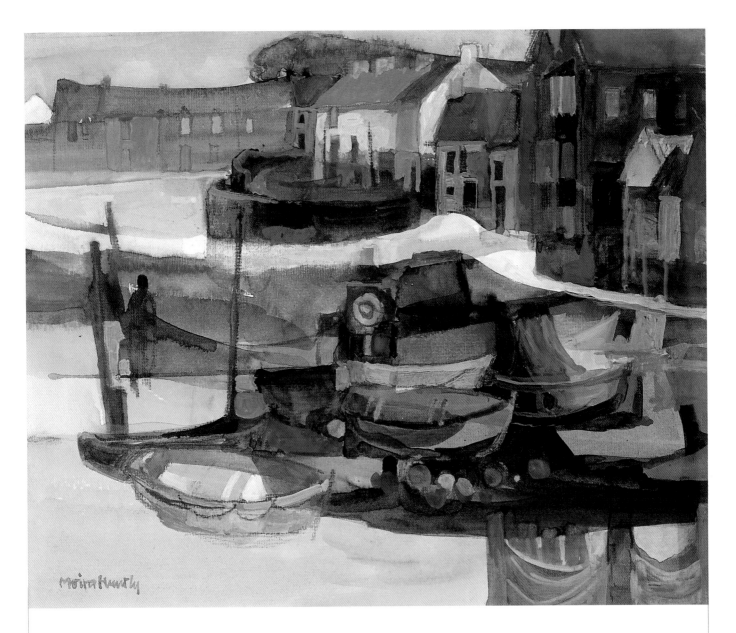

The Beach at Teignmouth

▲ Teignmouth is a busy south Devon coastal town, and my painting was inspired by the drawing on the left, but without slavishly copying it. I like to think of it as an interpretation, a distillation of parts of the drawing, choosing to include some but not all of the buildings, and some but not all of the boats. Warm colours – raw sienna, burnt sienna and burnt umber – dominate, contrasted with blues and mauves. *Watercolour, 34 x 36cm (12 x 15in)*

Kingsbridge, Devon

▼ Ultramarine blue and burnt sienna predominate, and white gouache has been worked into the blue washes to create light on the water. Thicker white gouache has been painted on the cabins and the sky is a deep summer blue. Floats and ropes add interest to the composition, and touches of definition have been added with watercolour pencils. The painting is not a slavish copy of the sketch, since boats from other drawings have been incorporated, but I am careful to keep to drawings of boats from the Devon area and not introduce boats from other parts of Britain's coasts. Knowledgeable boat enthusiasts would immediately notice the incongruity. It is interesting to note that the painting has a horizontal format based on a vertical format drawing. *Watercolour and gouache, 26 x 36cm (11 x 15in)*

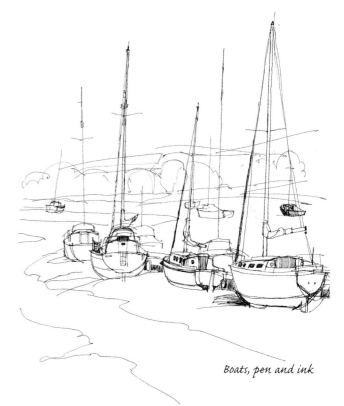

Boats, pen and ink

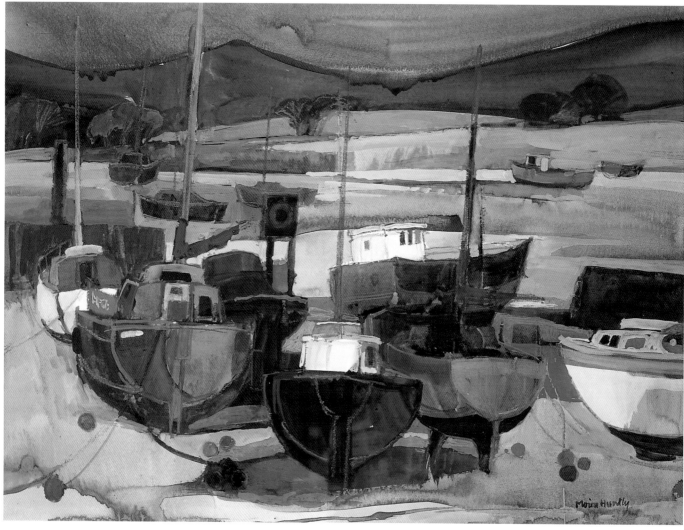

Kingsbridge is a busy market town at the head of the Kingsbridge estuary on the south Devon coast. Here I found plenty of moored boats and sailing boats beached on mudflats as the tide went out, masts at different angles and varying heights and furled sails. All these observations are important to the overall visual pattern.

Boats at Kingsbridge, pen and ink

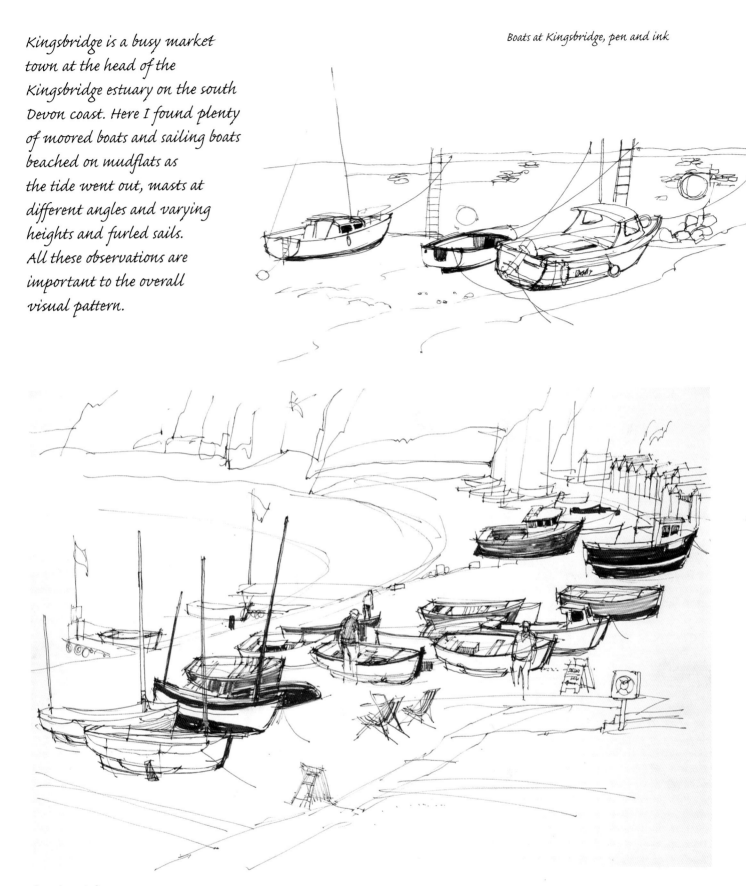

Boats at Beer

▲ Walking the cliff path, I came across this beach with its wonderful jumble of boats. Viewed from above, the sweep of the bay, the beach huts, cliffs and the variety of boat shapes made this a satisfying subject to draw. Touches of colour add to the pattern of boat shapes. *Pen, ink and felt-tip pen*

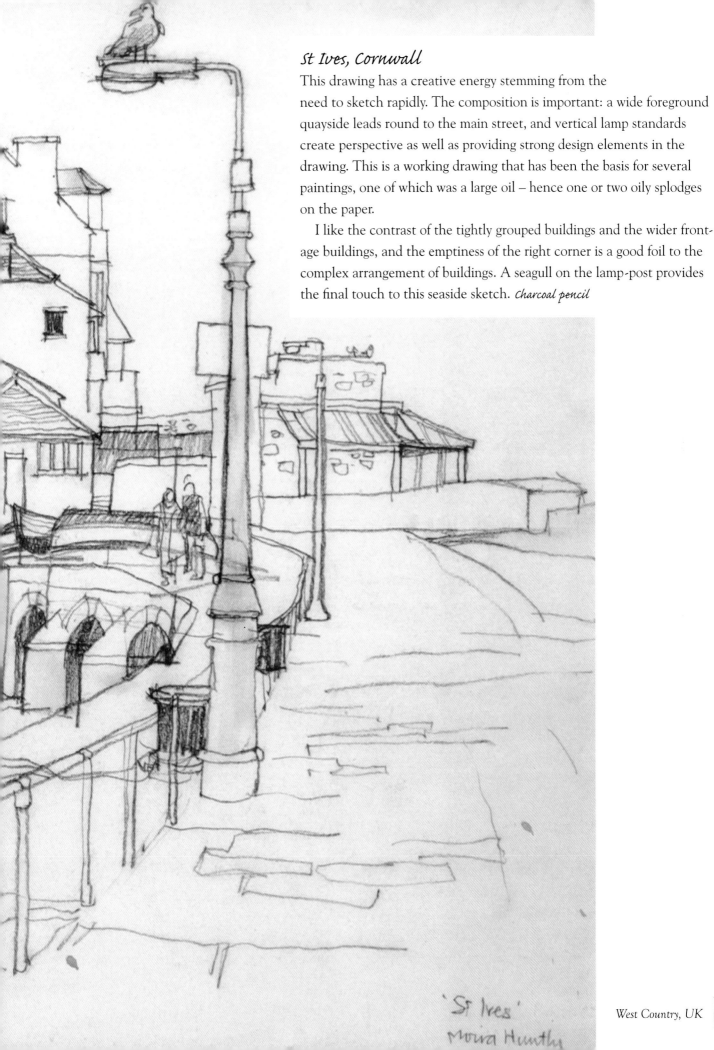

St Ives, Cornwall

This drawing has a creative energy stemming from the
need to sketch rapidly. The composition is important: a wide foreground
quayside leads round to the main street, and vertical lamp standards
create perspective as well as providing strong design elements in the
drawing. This is a working drawing that has been the basis for several
paintings, one of which was a large oil – hence one or two oily splodges
on the paper.

I like the contrast of the tightly grouped buildings and the wider front-
age buildings, and the emptiness of the right corner is a good foil to the
complex arrangement of buildings. A seagull on the lamp-post provides
the final touch to this seaside sketch. *charcoal pencil*

'St Ives'
Moira Huntly

Lyme Regis was originally a medieval port but is now a popular seaside resort on the Dorset coast. Once I had started this drawing I couldn't stop; I drew this panorama purely for enjoyment's sake.

Lyme Regis

▲ A fantastic long frontage, where to start? First of all I decide how much I want to include, and estimate that I will need to use two pages of the sketchbook. I started on the left and worked my way along, measuring by eye, continually checking horizontals and verticals. With practice this becomes an automatic procedure. Relationships are important, for example the proportions of windows are individual to each building. By the time I reached the church I needed to look again and make comparisons, such as how high is the church tower compared to the tall building on the left? Touches of felt pen reminded me of the kaleidoscope of colours: donkey brown, pink, black, slate, ginger and orange brick. *Pen, ink and felt-tip pen*

Cliff Path Plants, Devon

▶ Farther along the cliff path there was a convenient seat for me to take a breather, and around me I noticed the lush growth of plants. Small detail drawings can be useful reference, especially for foregrounds in paintings. These leaf shapes were varied, and the cow parsley provided a strong design element. *Pen and ink*

Port Isaac Back Street

▶ I made a brief stop to make a quick charcoal pencil drawing on an early evening walk down the hill to a favourite pub. I especially liked the view looking down the narrow street with its lanterns and pub signs adding visual interest. Figures also add interest but need to relate in scale to the height of doorways and windows. *charcoal pencil*

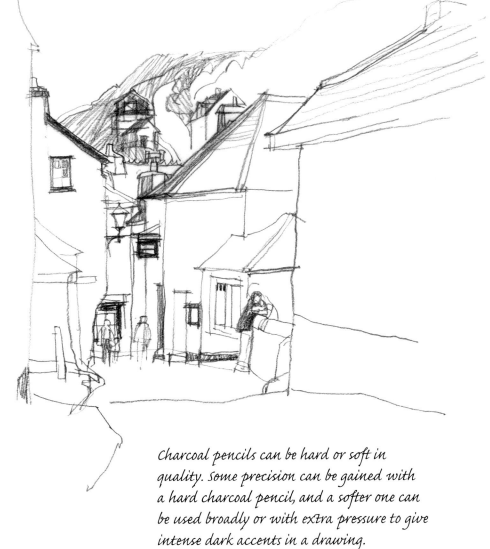

Charcoal pencils can be hard or soft in quality. Some precision can be gained with a hard charcoal pencil, and a softer one can be used broadly or with extra pressure to give intense dark accents in a drawing.

VANCOUVER, CANADA

Vancouver has been called the 'Gateway to the Orient', an exciting scenic city on Canada's Pacific coast, surrounded by water and mountains. I visit regularly because many of my family and friends live in Vancouver and Vancouver Island, which is a few miles off the coast. Everything in Canada seems vast, even the sky seems bigger.

Touchdown was nine hours later after flying mostly over barren, snow-covered land and frozen sea. The North-West Territories are seemingly endless; snowy white gives way to a dark Payne's grey and pewter-coloured landscape with a frozen white pattern of oxbow rivers. The landscape changes again to a checkerboard pattern of white squares and rectangles, separated by a thin network of dark lines and the occasional pewter-coloured square. This view from 37,000 feet could be the inspiration for many abstract paintings.

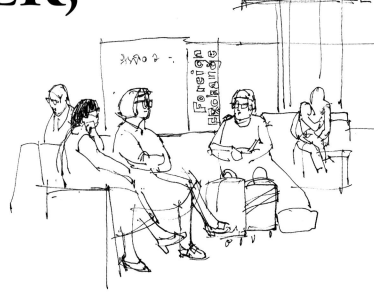

Departure Lounge, pen and ink

Checking in at Heathrow

▼ ▲ Arriving at Heathrow in good time for the flight meant there was plenty of time to do some sketching. People in the departure lounge make good subjects because they often sit still for some time. *Pen and ink*

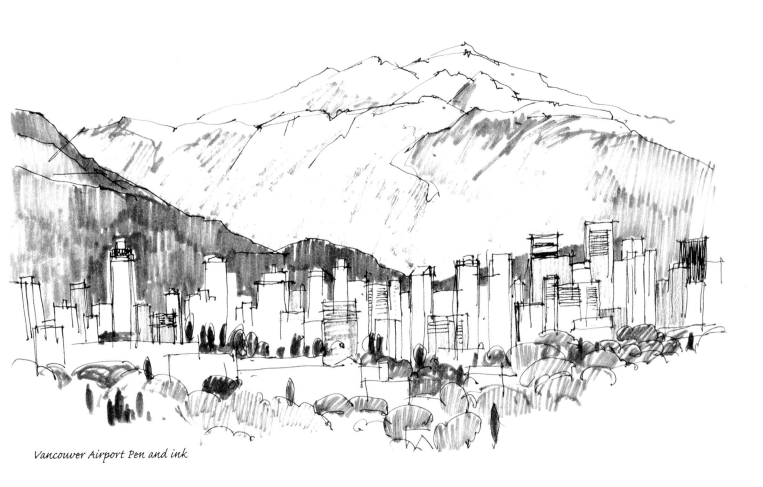

Vancouver Airport Pen and ink

Vancouver Panorama

▲ This wonderful view from the bedroom window
characterizes the city: tree-lined streets and avenues,
and lots of skyscrapers surrounded by mountains with
fresh snow on the peaks. The other essential feature
of Vancouver is the busy waterway that lies between
the skyscrapers and the mountains, not visible from my
vantage point. *Pen, ink and felt-tip pen*

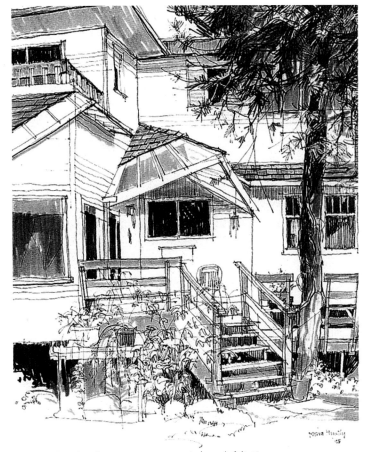

Our Destination in Vancouver, pen, ink and felt-tip pen

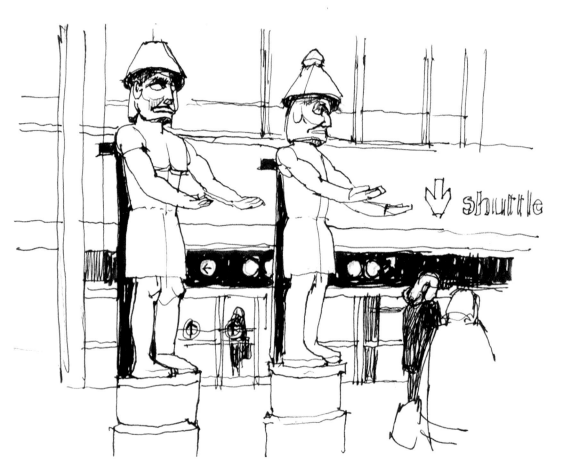

My journey to Vancouver as usual started and
ended at airports and I knew that I would be
spending plenty of time waiting. It is useful to
have a small sketchbook handy at these times;
being busy drawing relieves the tedium nicely.

Vancouver Airport

▲ On arrival in Vancouver I was awake enough to draw
the large welcoming wooden figures with outstretched
arms beckoning you to the exit at Vancouver airport.
Pen and ink

Street Furniture

▶ Another subject to draw while waiting. It was done
simply because I like drawing and as soon as I started I
found it very interesting. *Pen, ink and felt-tip pen*

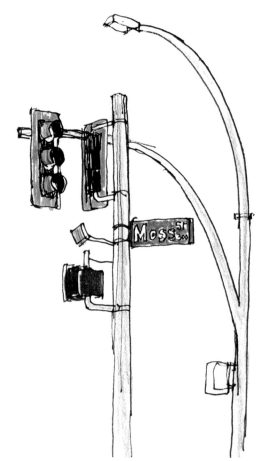

View from Earl's, Fir and West Broadway

▼ Fir and Broadway are street names, and Earl's is a nice restaurant where I was fortunate to sit at a table with a view. One of the group was late arriving so I took the opportunity to do a quick sketch while waiting. The waitresses were very interested. *Pen and ink*

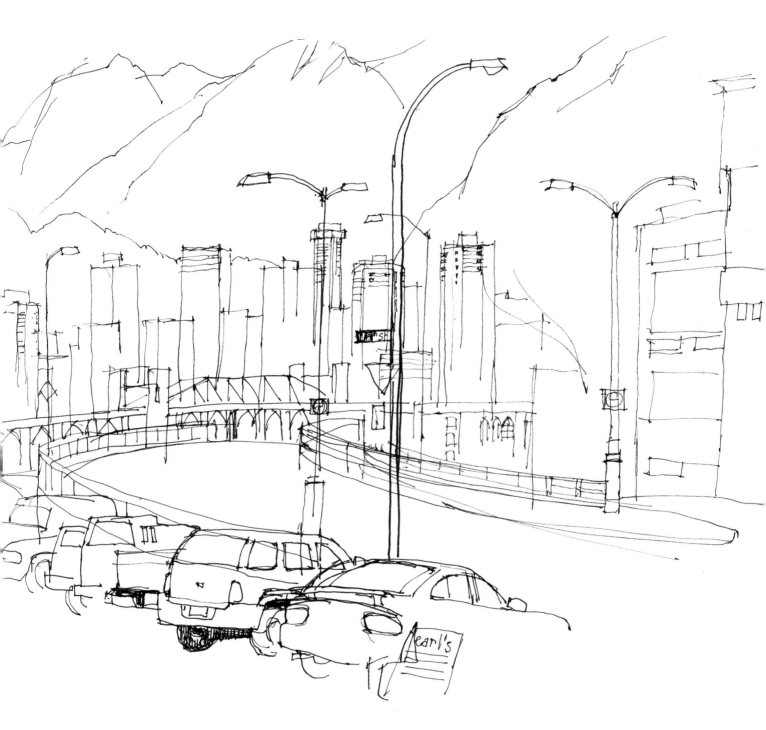

Granville Island is an area on the waterfront next to the Burrard Bridge; it boasts many arty shops, wonderful food markets, theatres, an art school, a large marina and plenty of buskers. I wish I could have stayed longer, there was so much to draw.

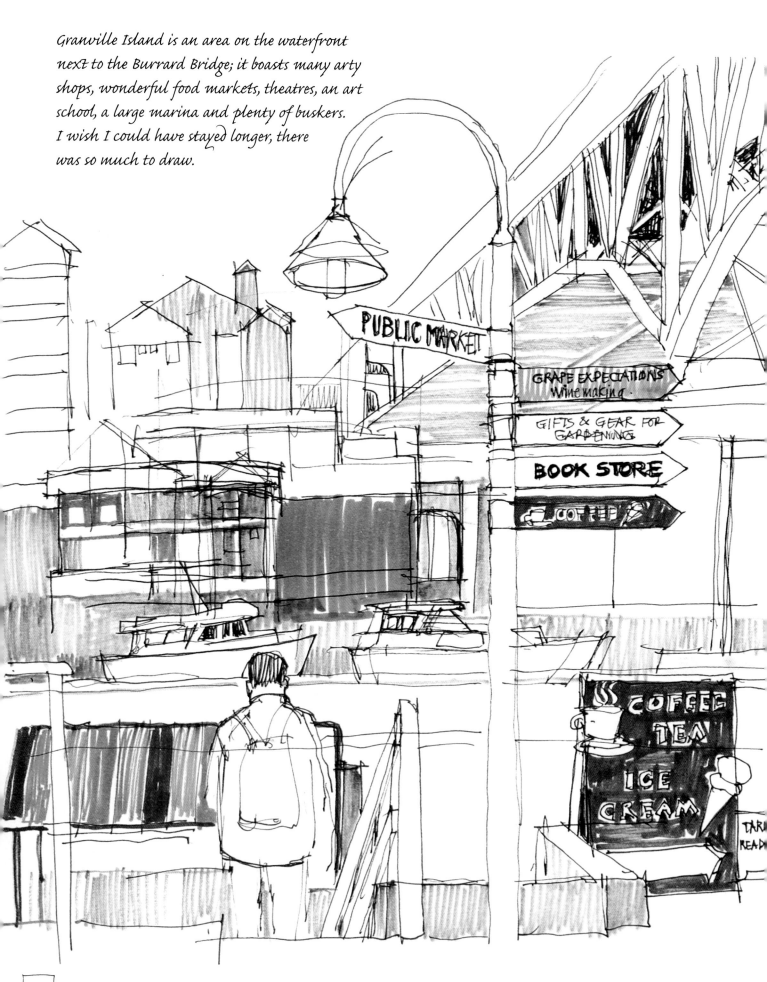

PUBLIC MARKET

GRAPE EXPECTATIONS
Wine making

GIFTS & GEAR FOR GARDENING

BOOK STORE

COFFEE

COFFEE
TEA
ICE
CREAM

TAR
READ

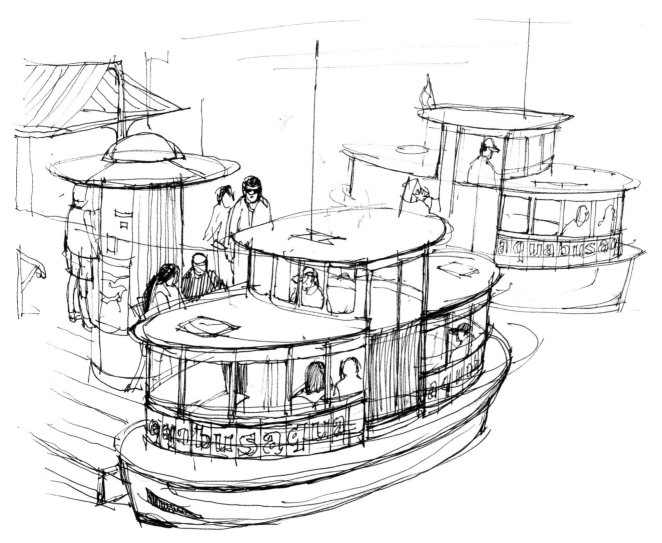

Aquabus Stop, Granville Island

▲ These small craft are very fast and are continuously scudding across the creek to 'bus' stops on the other side. I didn't get time to finish drawing one before it was off again, but I didn't have long to wait before another one arrived. I had to be patient and hope that the next aquabus would dock in approximately the same position as the last. The stops have colourful awnings, stripes of blue, pink, red, orange, yellow and green, and the colours were repeated on the aquabuses. *Pen and ink*

Granville Island

◄ I sat at the top of the steps to the aquabus stop and no one took any notice of me at all, so I was pleased to be undisturbed. There is a variety of subject matter in this sketch, boats, buildings, amusing street signs, a street lamp and a figure. *Pen, ink and felt pen*

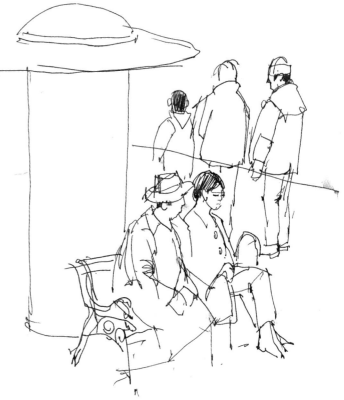

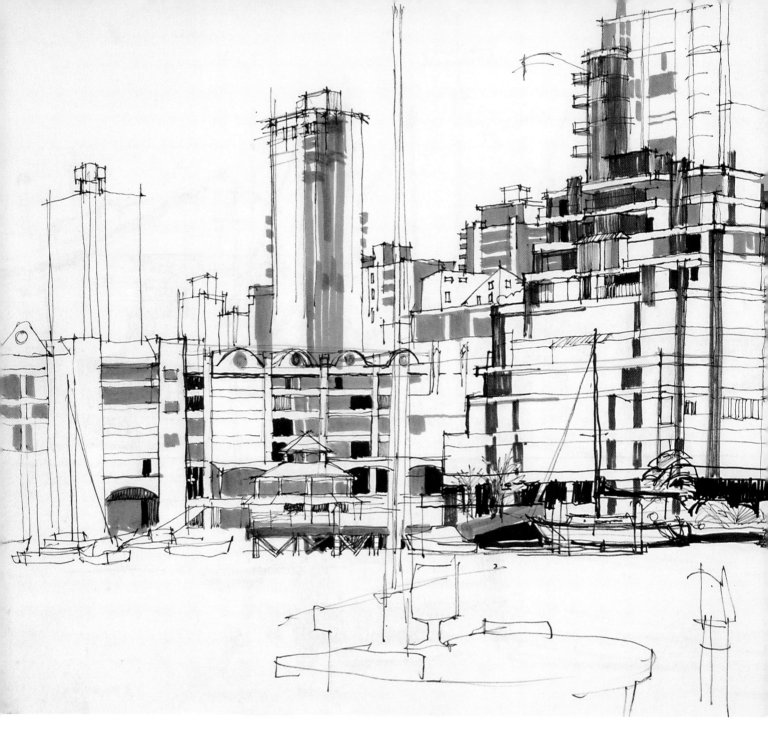

Drawing a subject that is vast in scale can be daunting. A good start can be made with a skyscraper subject by drawing lots of vertical lines using the edge of your sketchbook as a reference to keep the lines vertical. Once these lines are established, you can add details.

Vancouver Waterfront

▲ This view is of downtown Vancouver through the windows of a waterfront café on a rainy afternoon. Though the sketch is unfinished there is enough information because much of the construction is repeated. Boats moored at the quay across this stretch of water (known as False Creek) give scale to the towering buildings beyond. *Pen, ink and felt-tip pen*

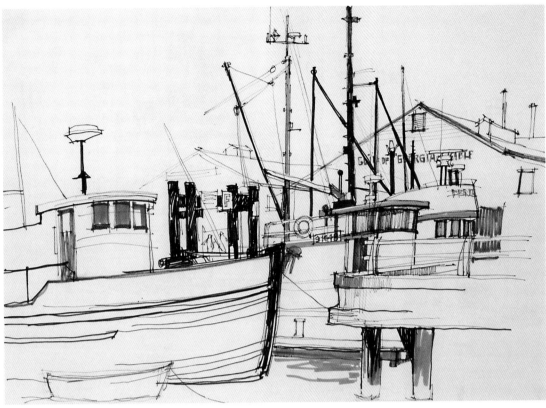

Steveston BC

▲ I always enjoy visiting Steveston, a busy fishing town south of Vancouver. In this sketch there is a pattern of black shapes, sturdy masts and heavy wooden mooring posts, typical of this part of Canada. The fishing boats are quite large and the fishermen friendly. They are always interested to see if I am drawing their particular craft. *Pen, ink and felt-tip pen*

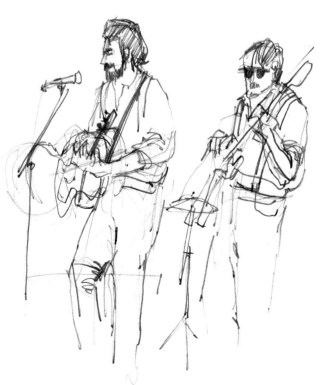

Buskers on the Quayside

▶ People are fascinating to draw. Try to capture the general stance and wait for any repetition of movement, which can apply particularly to drawing musicians. A captive audience also provides good subjects. *2B Pencil*

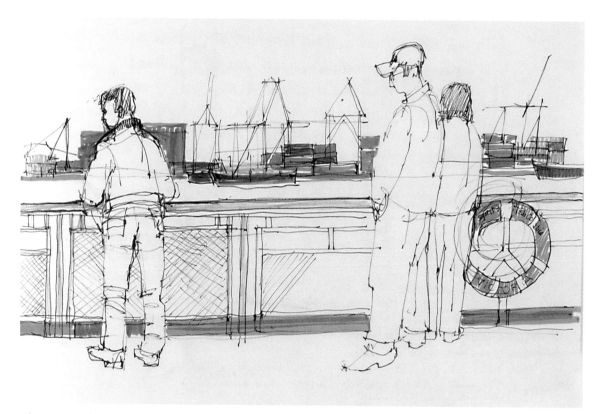

Above: On Deck, The BC Ferry 'Spirit of British Columbia', pen, ink and felt-tip pen

The ferry to the island left Tsawwassen on the outskirts of Vancouver at 5pm and the crossing took about two hours. It was a perfect evening, the water was as calm as a mill pond and the evening light showed the other islands and distant mountains to great effect. The ferry is huge, with several decks to accommodate hundreds of cars and enormous trucks as well as coaches. Vancouver Island is extremely large, in fact a little larger than Belgium. Inland, the mountain ranges tower to heights up to 7,200 feet, and towards the Pacific rim there are vast rainforests. I was headed for my brother's home in Brentwood Bay, close to the Butchart Gardens to the south-east of the island, near to Victoria, the capital city of British Columbia.

I managed to draw a few of the people who had braved the open deck as we left Tsawwassen, but although the sun was still shining, it was soon too cold and windy to sketch.

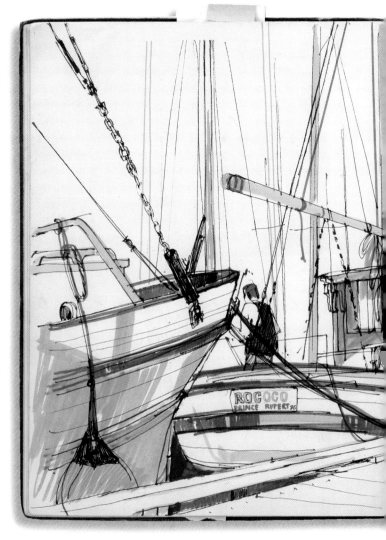

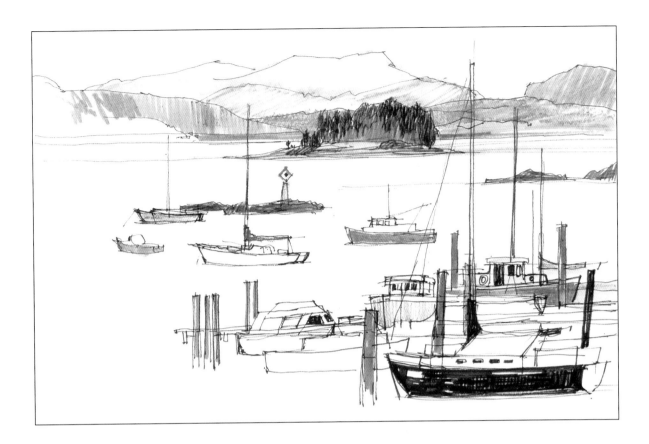

Brentwood Bay

▲ Another calm day, and the water was quite still in this idyllic view of the bay, which looked over part of the marina to the distant mountains with snow still on the peaks. I saw a long canoe being paddled out to the island in the bay, believed to be an Indian burial ground, but I needed a pair of binoculars in order to see it clearly.

It is difficult in a small sketch to convey the large scale of a subject. Here the mountains are a long way off and thousands of feet high, and I found the use of felt pens to have limitations when it came to aerial perspective because I didn't have a big enough range with me. I was wishing that I had taken watercolours instead, but the sketching opportunity was unplanned and I made do with what was in my pocket. *Pen, ink and felt-tip pen*

Campbell River, Vancouver Island

◀ Campbell River is a busy port on the east coast of Vancouver Island about 140 miles north of Brentwood Bay. It is home to many big luxury yachts, some belonging to famous film stars, as well as large numbers of fishing boats, their multitude of masts looking just like a forest on water. *Pen, ink and felt-tip pen*

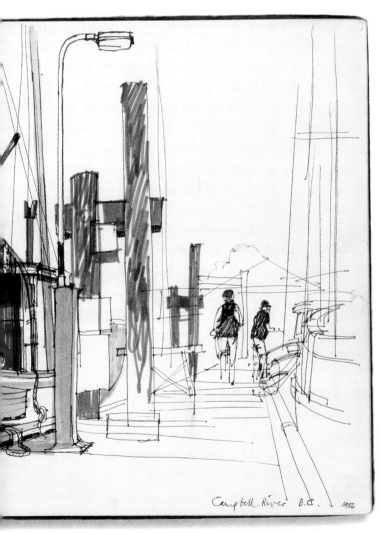

Campbell River B.C. 1986

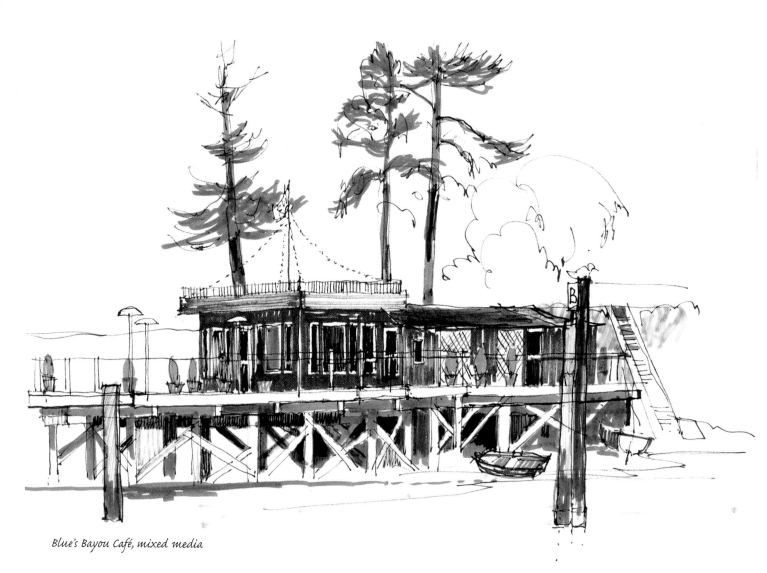

Blue's Bayou Café, mixed media

Blue's Bayou Café is my favourite eating place on Vancouver Island. It is in a wonderful setting built out over the water and festooned with fairy lights that sparkle and dance over the water at night. Excellent food and friendly service, so friendly that I asked if I could return next day to make sketches.

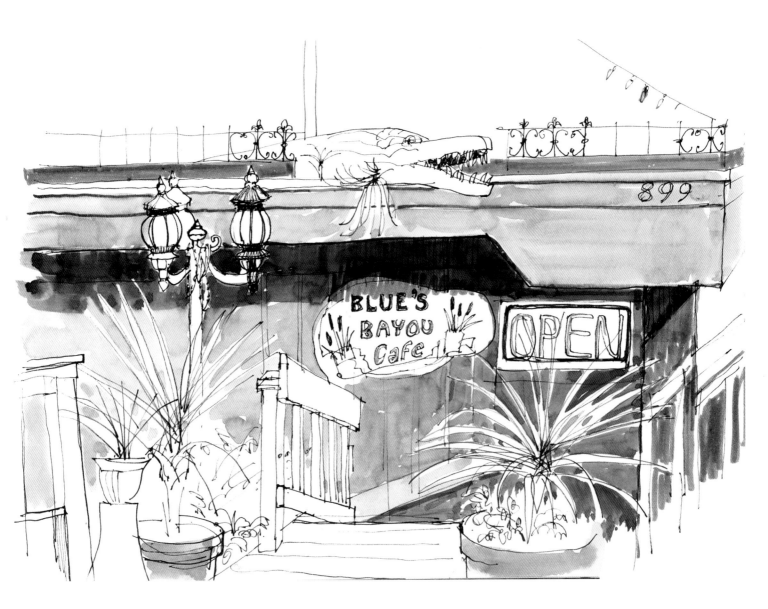

Blue's Bayou Café

▲ Returning in daylight, I realized that there was a model alligator leaning over the entrance that I had failed to see in the dark the night before. Maybe that was just as well. A delivery man stopped for a while to watch me draw, then I got rained off with a sudden squall and it was cold, so I headed into the warmth of the café. I spent an enjoyable hour drawing some of the bric-à-brac that adorns the walls while listening to background music which was, as you may guess, jazz. *Pen, ink and watercolour*

▶ This café also boasts the most original toilet directions I have ever seen and I just had to draw the sign. Next day I took the ferry back to Vancouver and from there a flight back home, with a sketchbook full of memories and images to inspire. *Pen, ink and felt-tip pen*

SPAIN

I have early memories of Spain, having lived in El Ferrol in Galicia for the first four years of my life, but many years were to elapse before I returned. My most recent visits were to Granada, a city in Andalusia that is justifiably popular with artists, writers and musicians, and a few years later to the hill village of Rupit in Catalonia in the north-east. Both these places provide a visual feast for the artist, with subjects round every corner.

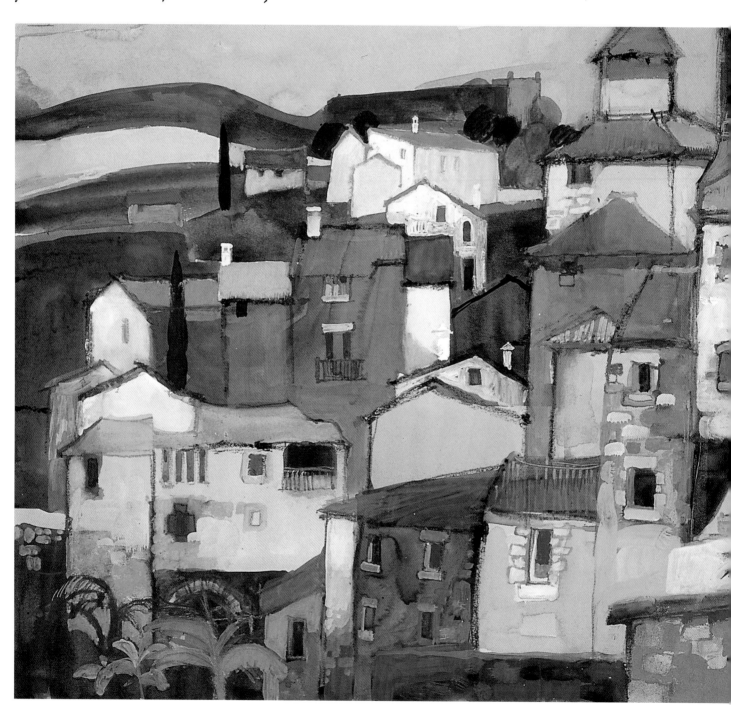

Rupit, Catalonia

▼ This watercolour was painted in the studio and is an interpretation of Rupit inspired by several sketches and my memory of the warmth of the hot midday sun.

Colour can evoke a mood or relate to the time of day and so the colours I chose for this painting related to the temperature, mainly reds, oranges and yellows. The palette is limited, and warm primary colours are contrasted with a cool neutral dark colour, Payne's grey. Warm dark tones can be achieved by mixing a little red or orange into Payne's grey, and a small amount of yellow with Payne's grey gives a subtle olive green. Touches of white gouache bring an extra sparkling light to some of the buildings. I find that using a limited palette can help to create unity in a painting. *Watercolour and gouache, 29 x 41cm (12 x 17in)*

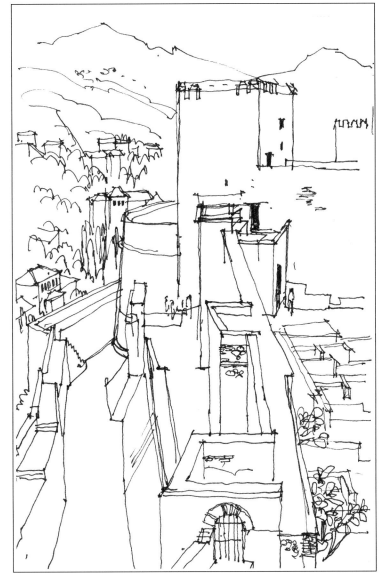

Alhambra Palace Walls, Granada

◀ I used a small 24 x 17cm (10 x 7in) sketchbook for this quick sketch of the palace walls. Definitely not the usual tourist view of the Alhambra but a viewpoint which gives an impression of the towering dominance of the palace over the city below.

Pen and ink

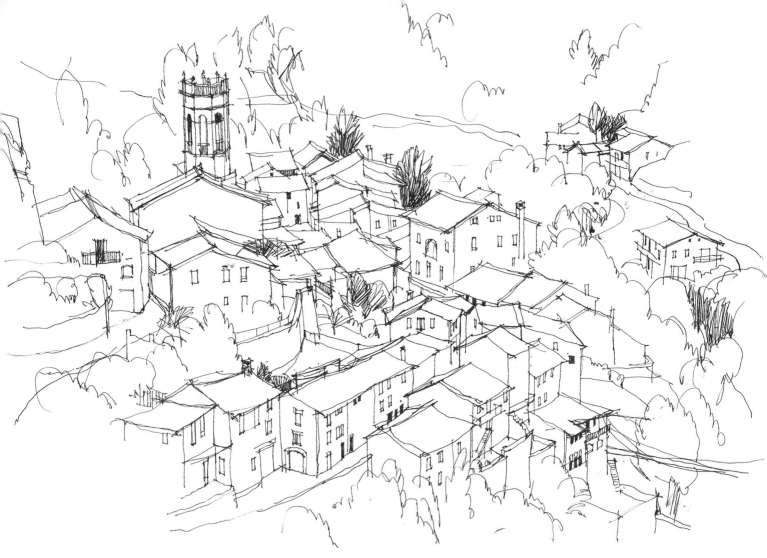

Rupit is an attractive inland stone-built village, where I spent a week making many drawings that have been the inspiration for paintings ever since. Quite often artists needlessly spend a lot of time and energy travelling miles looking for subjects when there are many right under their noses.

Rooftops, Rupit

▲ I climbed to the highest vantage point to look down on the whole of this Catalonian village and the view was worth the trek. Where to start the drawing of this complicated subject? Well, I decided that the church tower should be the focal point, and all the rooftops seemed to follow in a circular movement towards the tower. I used a fine Profipen No. 3 and each house was drawn in relation to the next, constantly looking at the church tower as a reference point to compare heights and widths. Drawing with a pen worries some people because you can't rub out; however, where I want to make alterations to my drawing I simply re-draw over the initial lines, and the unwanted marks soon merge into the background. *Pen and ink*

Rupit

▶ The combination of charcoal pencil and felt pen is ideal for a chiaroscuro drawing – that is, the representation of light and shade in a work. The warm grey felt tip blends well into the charcoal pencil, varying the tones. Here is the by now familiar church tower seen from a different vantage point. The dark wooded area in the background emphasizes the light on the buildings. *Charcoal pencil and felt-tip pen*

Rupit, Spain

▶ I have experimented with watercolour, charcoal, pastel and gouache here. The use of charcoal creates mystery and atmosphere in this chiaroscuro painting based on the drawing below. As in the drawing, light areas are emphasized by the dark tree-clad hillside behind, but this time the church tower is partly hidden in deep shadow. This painting has a totally different atmosphere to the watercolour page 54. On the day I did the original sketch I had experienced thunder and heavy rains, turning the narrow streets into gushing rivers, so maybe this memory has influenced the painting. I can look at a sketch drawn years ago and am often able to recall the mood of the day. *Mixed media, 24 x 22cm (10 x 9in)*

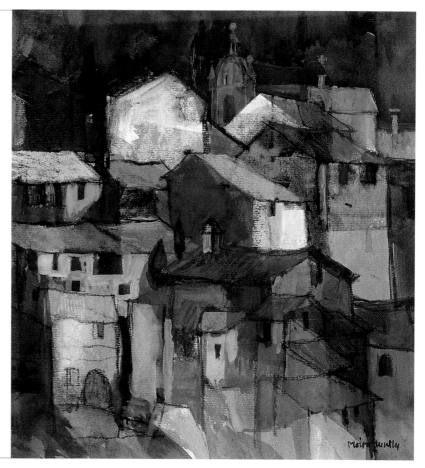

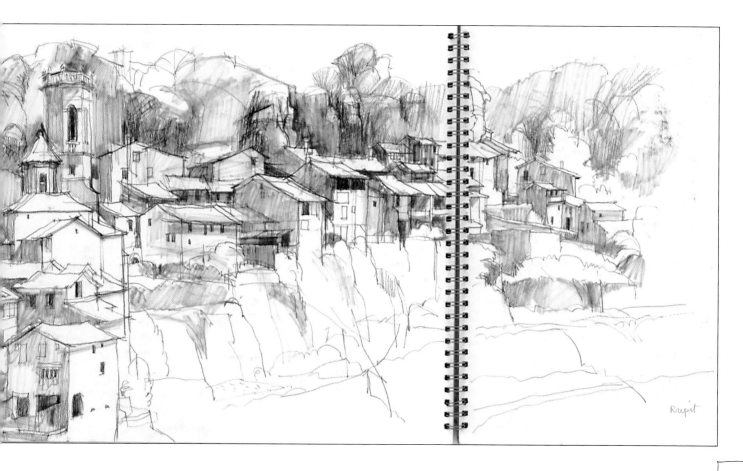

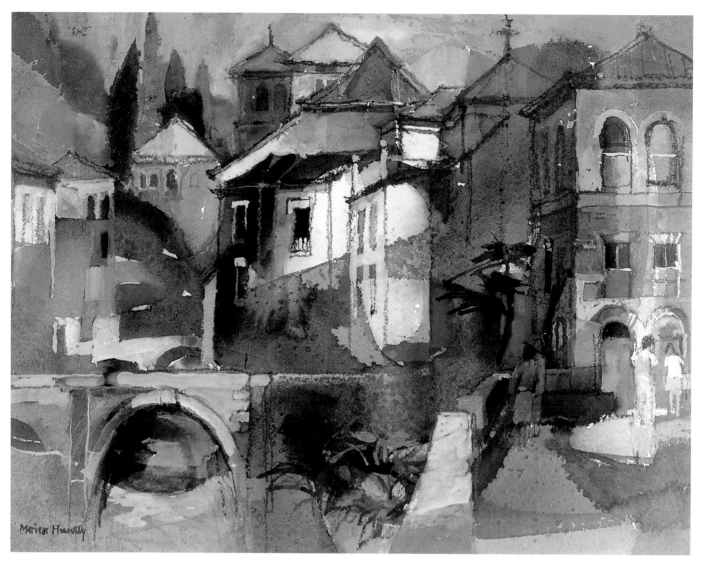

Granada

▲ Spain in October is delightfully warm and I have used warm colours in this painting, a pale overall wash of raw sienna, burnt sienna, pale olive green and burnt umber, touches of orange and a soft Mediterranean blue sky. Dappled light has been created on key areas of the painting: the bridge, the central buildings and the figures.

Watercolour, 24 x 34cm (10 x 14in)

Evening, Granada

▶ This is quite a different interpretation of the same subject and in a different medium. Pastel has been used to create the drama of warm evening light and an intense deep-toned sky with indigo and rich purples. I wanted the buildings to seem to be holding the warmth of the day.

Pastel, 43 x 50cm (18 x 21in)

Two paintings in different media, but both based on the drawing made behind the Inglesia de San Pedro, Granada, shown on the right.

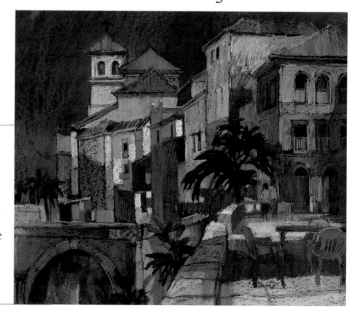

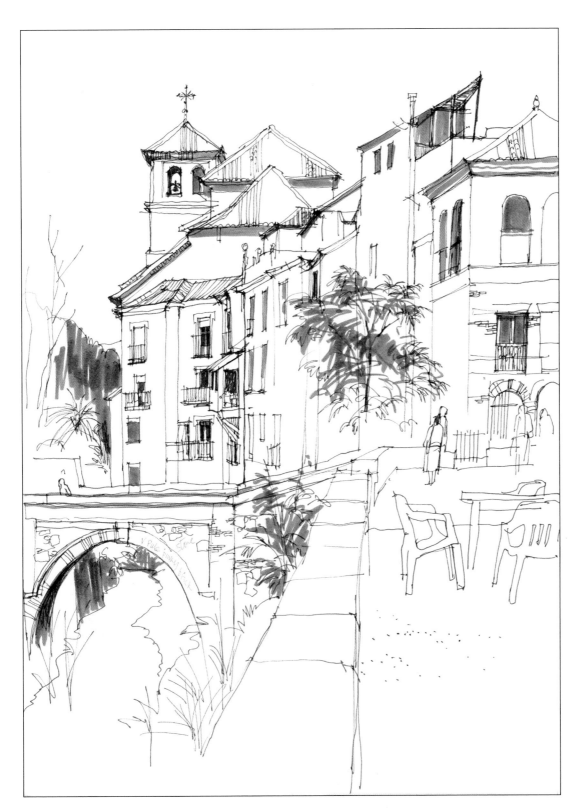

Behind the Inglesia de San Pedro

▲ Sketching can be hazardous at times, and to get the view that I wanted for this sketch I had no choice but to perch precariously on the wall. On my left was a steep drop down to the River Darro and on my right was a narrow street without a pavement. Unbelievably, a large coach came right down the street and the driver had to negotiate his wing mirror past my head as I leaned out as far as I dared over the river. After that close shave my drawing speeded up remarkably in case a second coach should approach! There were so many good features to sketch – the church, buildings, a bridge, figures, trees and plants – so I persevered and didn't abandon my spot.

Brown ink pen and felt tip pen

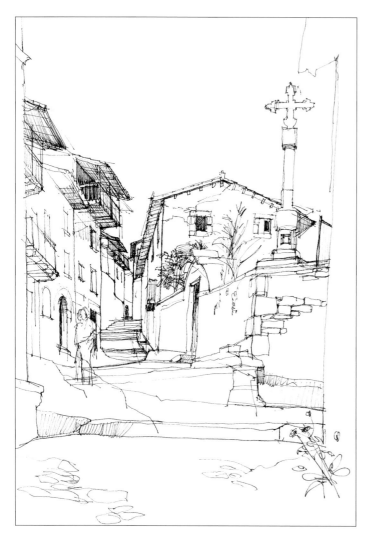

These pictures are typical of the narrow stone-stepped streets and generous overhang of roofs that provide shade in hill villages such as Rupit.

Rupit

◀ As I drew I compared the angle of each slanting roof with its opposite number across the street, and as a back-up to these observations I looked hard at the amount of sky seen between the buildings. It makes an interesting zig-zag shape.

Looking up the street the perspective is steep, my eye level is low and so all lines above my position slope down towards an imaginary horizon that always coincides with the eye level. From my vantage point the stone cross seems to tower above all the other buildings whereas in reality it is probably not as tall. Such scale and perspective problems can be solved by keen observation without any knowledge of theory. *Pen and ink*

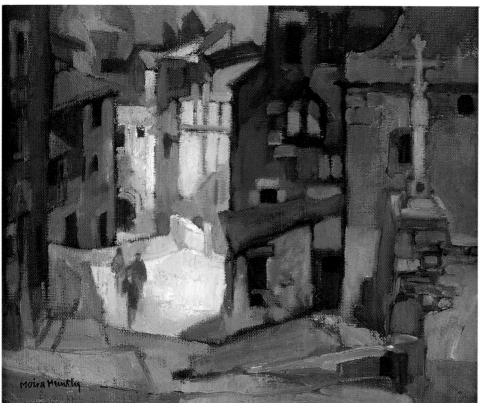

Rupit, Catalonia

◀ Based on the high eye-level sketch (right) looking down one of the village streets, this painting is of a horizontal format as opposed to the vertical sketch, and many adjustments have been made to the composition. It is an interesting exercise to rearrange elements in a sketch and create a different composition. The colours are warm and rich, the foreground low in tone and the lightest areas focused down the street. A glimpse of bright green hillside can just be seen above the rooftops. *Oil, 22 x 29cm (9 x 12in)*

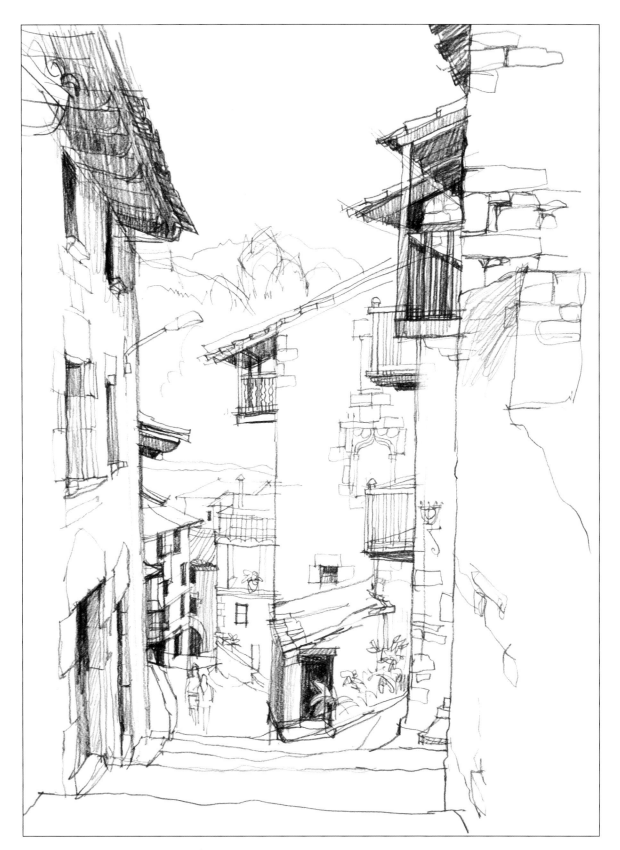

Back Street, Rupit

▲ For this sketch I was standing at the top of the street looking down, so my eye level was high. Roofs above my head still slope down to my eye level, but the base of the buildings slope up. My eye was approximately on a level with the base of the central balcony. Again, I compare the position of each roof with the next, and look at the in-between shapes of hills and sky seen through them.

Conté pencil

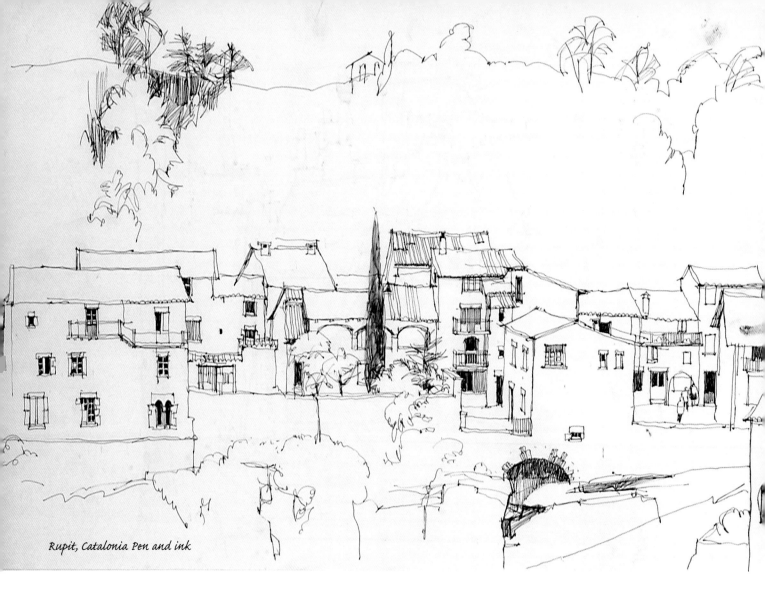

Rupit, Catalonia Pen and ink

Rupit, Catalonia

▲ I found a vantage point from where I could look across at a panorama of almost the whole of the village. It was a hot day and I was lucky to find shade under a tree. The drawing started on the right-hand page of the sketchbook with the principal church tower and the backdrop of rock faces and wooded slopes. Buildings and roof shapes surrounding the church tower are all individual in structure, adding to the interest of the sketch. As the drawing progressed to the inner edge of the page I knew that I wanted to open out the sketchbook and continue with the panorama of buildings. As the drawing moved on I continually made comparisons with the heights and widths of buildings on the right-hand page. I think of doors and windows as patterns of squares or rectangles and note the varying levels as I draw. This act of constantly making comparisons as you draw becomes second nature after a while.

Eventually I ran out of page completely, but the village ran on! *Pen, ink and felt-tip pen*

▶ These little oil paintings were painted as a pair. Neither of them is a slavish representation of any of the wealth of sketches I have of this Catalonian village. I chose a cool range of colours for the first painting on the left, and an orange sienna sky for the second painting. A pattern of light is created when white paint is added to some of the buildings.

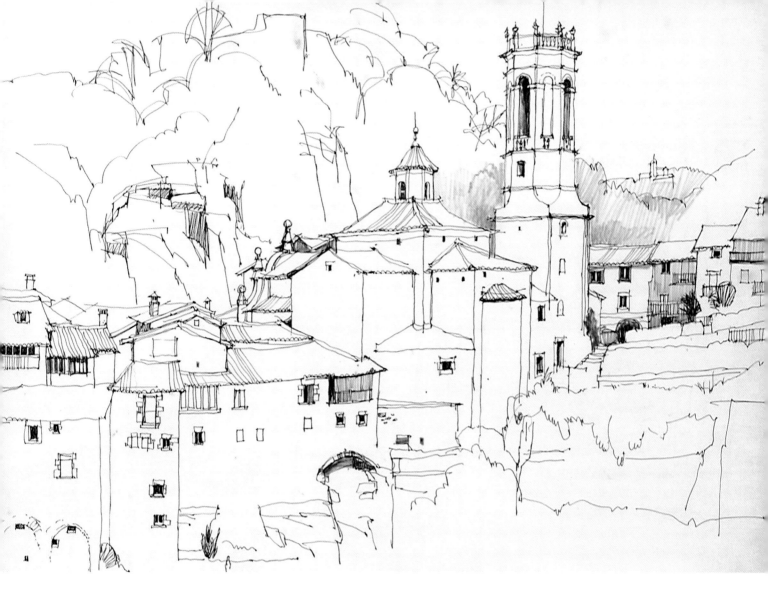

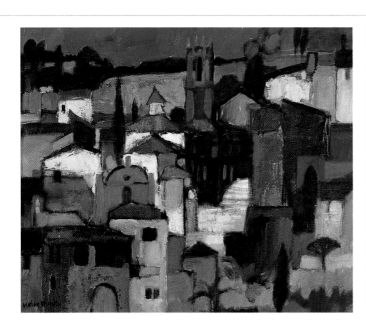

Rupit I, oil 24 x 29cm (10 x 12in)

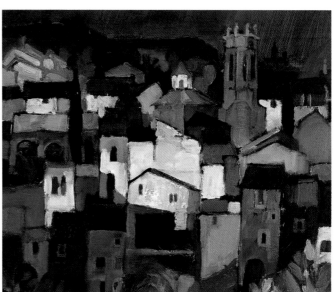

Rupit II, oil 24 x 29cm (10 x 12in)

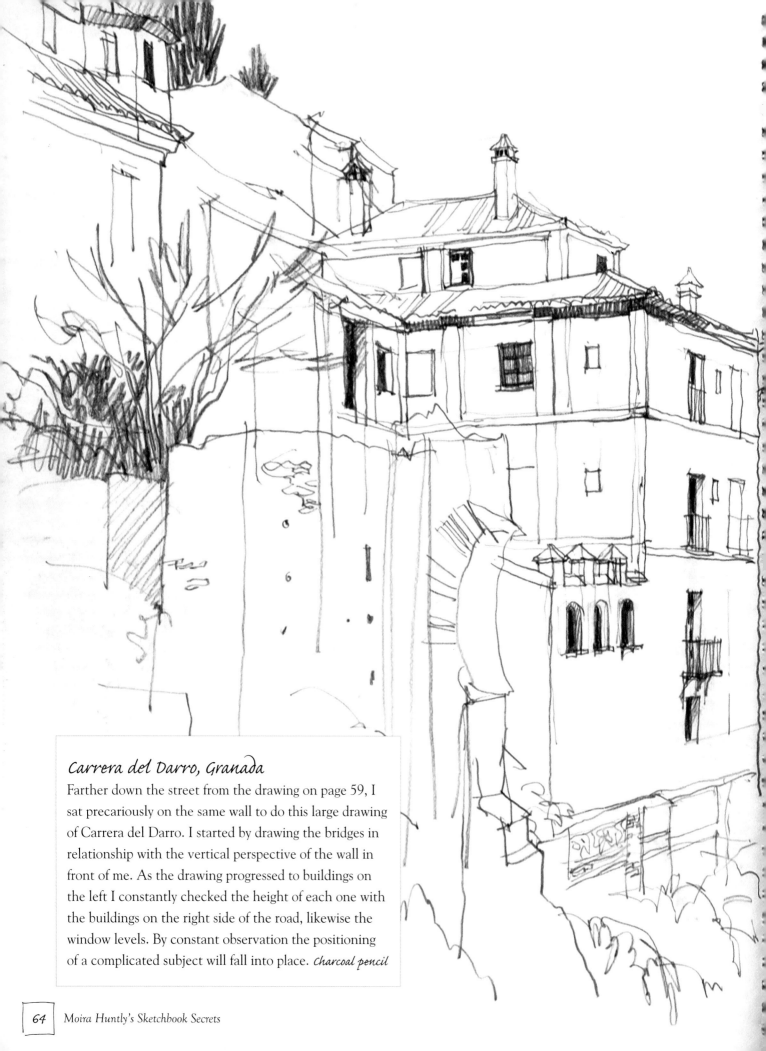

Carrera del Darro, Granada

Farther down the street from the drawing on page 59, I sat precariously on the same wall to do this large drawing of Carrera del Darro. I started by drawing the bridges in relationship with the vertical perspective of the wall in front of me. As the drawing progressed to buildings on the left I constantly checked the height of each one with the buildings on the right side of the road, likewise the window levels. By constant observation the positioning of a complicated subject will fall into place. *Charcoal pencil*

Charcoal pencil is a good medium to use when creating deep black shadows inside windows and doors as a sharp contrast to dazzling white sunlit walls. I enjoy the freedom of line and being able to vary the pressure to give soft sensitive lines or more pronounced lines with an increase in pressure. Granada is such an interesting city; I could have stayed drawing here for a year and not exhausted the visual stimulus for putting pen or pencil to paper.

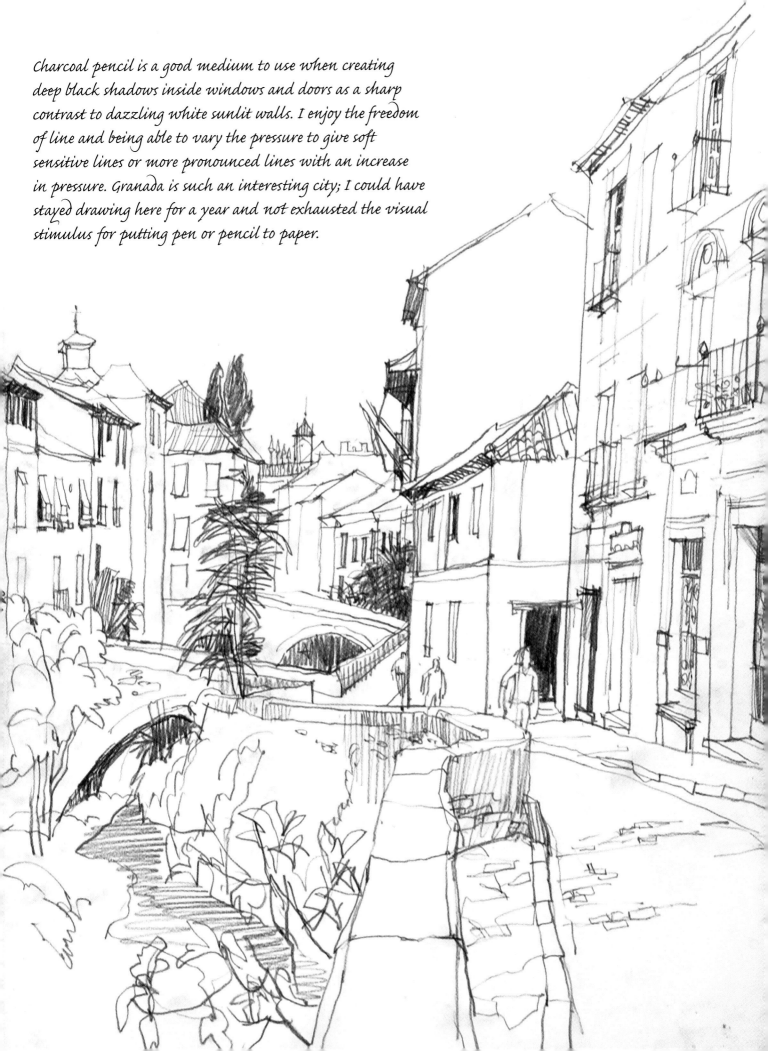

PORTUGAL

Portugal is a small and ancient country situated on the westernmost part of Europe. The Algarve coast in the south has many popular holiday resorts, but I prefer the west side of the Algarve which is not as touristy as the 'concrete jungle' of the easterly end. Towards the west the pace of life is quieter in many of the fishing villages, and inland there are plenty of unspoilt mountain villages with narrow, often very steep streets such as in the sketch of Monchique.

Monchique

▶ Steep streets present a few perspective problems. Here I was looking up the street, so my eye level was down at the bottom of the street, hence the buildings all slope down at different angles. Lanterns, hanging signs, wall lettering, striped canopies and figures all add visual interest. *Pen and ink*

Street in Silves

▼ This is another delightful inland village. Fine weather allows outdoor cooking in front of the street café, and I tried to capture the chef in action. Again, lanterns, advertising signs and figures are important ingredients in the sketch. *Pen and ink*

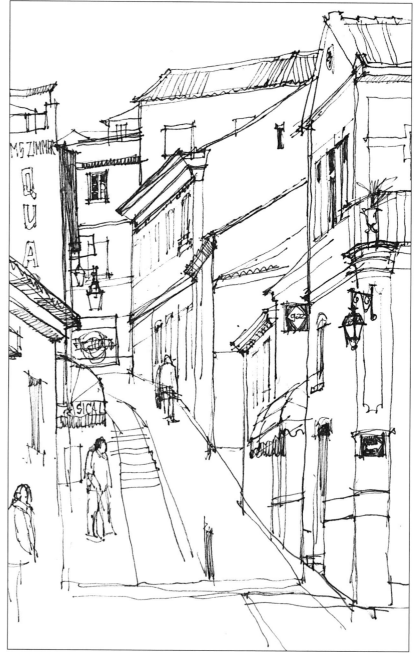

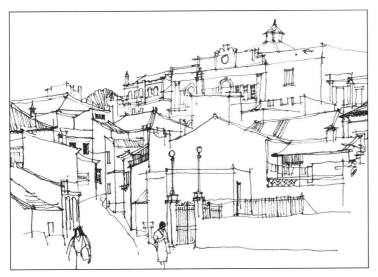

Silves

◀ A quick sketch of a jumble of buildings, differing in architectural style and proportion. I liked the unusually tall lamp-posts, the row of railings and, of course, the washing on the line drying in the Mediterranean sun.

I used a small 24 x 18cm (10 x 7in) sketchbook for all these drawings. It is easy to carry in a handbag or large pocket, and I can be relatively unobtrusive when wanting to make quick drawings. *Pen and ink*

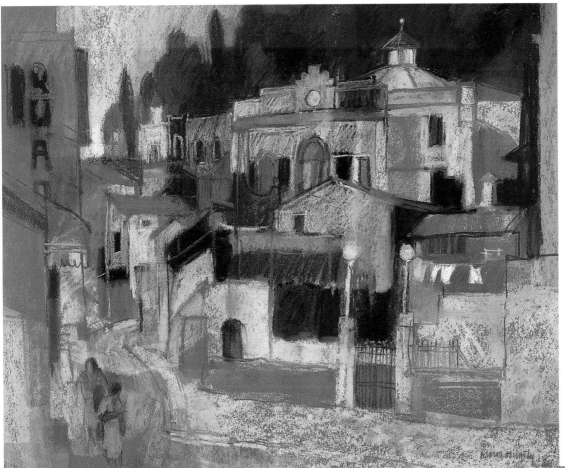

Hill Village, Portugal

▲ This painting based on Silves has been given a general title because I had taken a few artistic liberties with the original sketch, though it is still recognizable as Silves. It is based mostly on the sketch above, but the wall lettering on the left is taken from the Monchique sketch, and I allowed trees to 'grow' behind the principal building to create a rich dark background. I did this to emphasize the colour and light and warmth that permeates the buildings. This feeling of warmth is largely due to the colour of the support – a burnt sienna-coloured pastel paper – and parts of it have been allowed to show through. The warm-colour emphasis is intensified on the pantile roofs with touches of strong orange and red.

Pastel, 29 x 36cm (12 x 15in)

Along the Algarve coast is the fishing village of Burgau, and the drawings I made there have provided inspiration for many paintings. I love the architecture, the unusual chimneys and quiet atmosphere of the village. I came away wishing I could purchase one of the houses.

Burgau Back Street

▼ This is a quick drawing in brown Conté pencil with a few colour notes added in felt pen. Most felt pens are not permanent but suffice on a working drawing. I hoped that someone would sit on the bench, which would have made a nice addition to the sketch. *Conté pencil and felt pen*

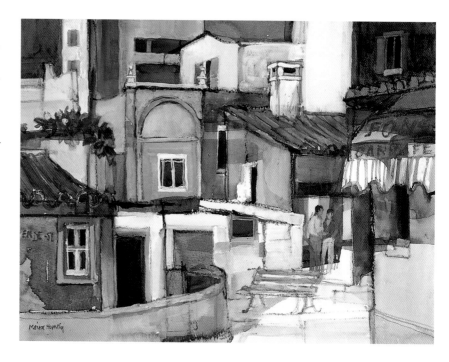

Burgau, Portugal

▲ The watercolour is an interpretation of the back street sketch. It is interesting to change the format sometimes and do a horizontal painting based on a vertical drawing. There are a few additions including some figures that I felt were missing in the drawing. *Watercolour, 24 x 34cm (10 x 14in)*

Portuguese Village

▶ Complementary colours, orange and blue, give a Mediterranean feel to this painting based on the drawing above right. In contrast to the warm colours on the buildings, the sky is intensely blue, and is reflected in the windows. Elements in the sketch have been juggled around, the farthest building is taller and its dome enlarged, the street is wider and there is a general simplification.

The fisherman in the foreground of the sketch was mending a net and kept eyeing me suspiciously. I wasn't sure whether he might object to being drawn, so every time he looked up I avoided eye contact and pretended to be drawing the buildings behind him. He grinned at me when I left, so I don't think I fooled him after all.

Burgau, pen and ink

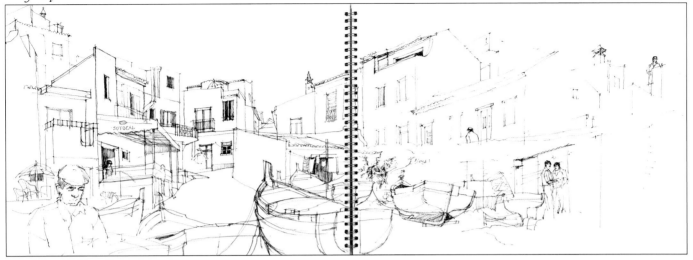

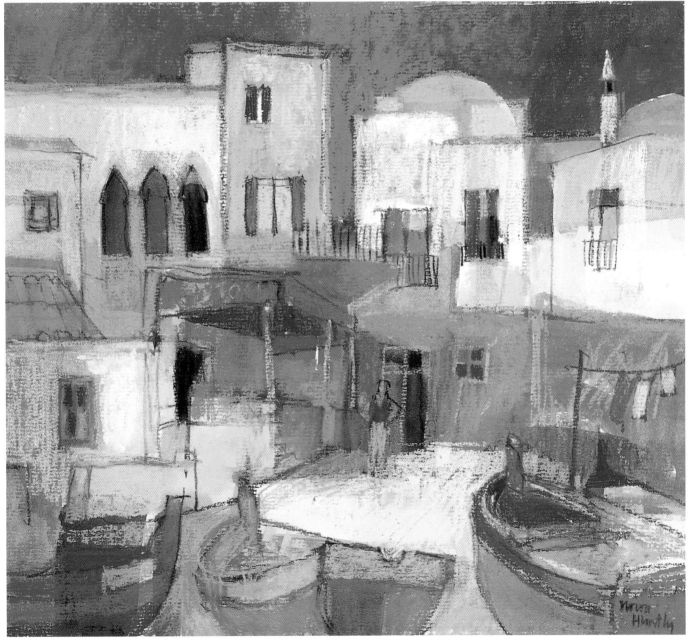

Portuguese Village, pastel, 22 x 24cm (9 x 10in)

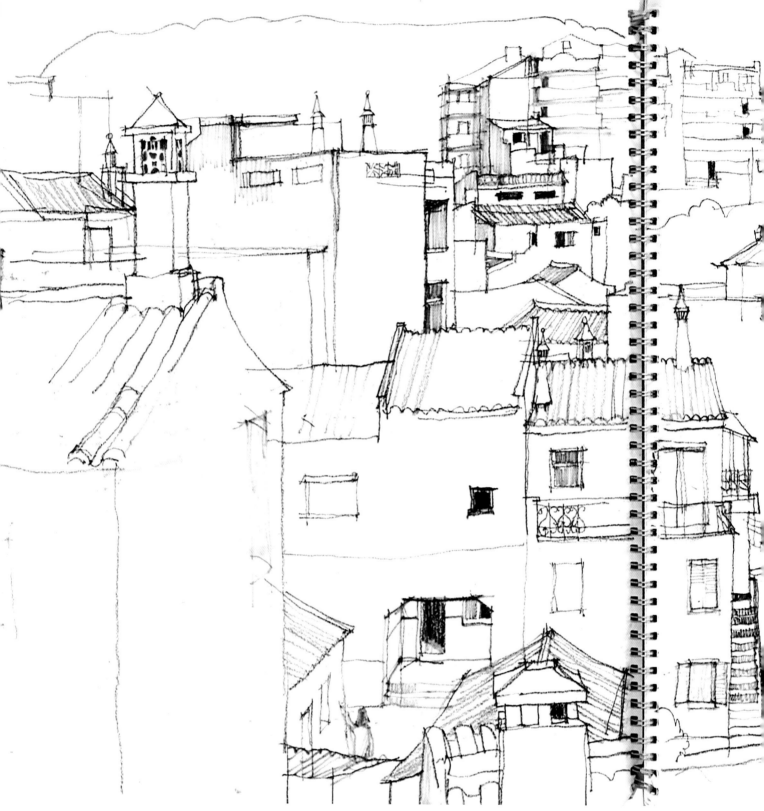

Burgau

It was a very hot day and I found a shady place to sketch under an angel trumpet tree, sitting with my back against a cool, whitewashed wall. I knew that the panorama of buildings before me was going to take some time to draw, so it was worthwhile seeking out a relatively comfortable spot. After a while a group of little boys came to find out what I was doing. They didn't disturb me, they just wanted to watch. As the drawing progressed, they began pointing out to me which house each one lived in. Suddenly they all disappeared, and the next time I looked up they were waving to me from their various windows and balconies!

Now, whenever I look at this drawing the memory of all those little boys appearing and giving me friendly waves makes me smile.

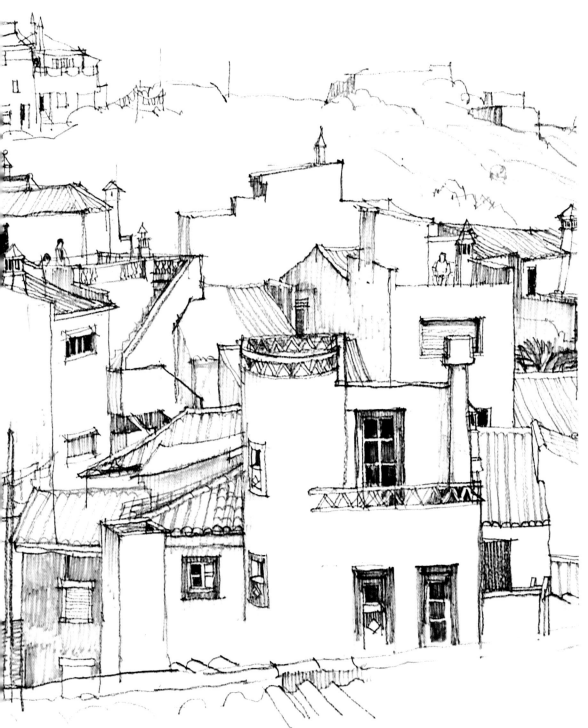

Here are just two
of the figures that
appeared briefly on
a balcony. There are
one or two more,
but you will have
to look quite hard at
the big drawing in
order to find them.

I travelled light because the weather was hot and I knew I had to walk up a steep path to gain a good vantage point, only carrying a sketching stool, large sketchbook, a black and brown Conté pencil and a grey felt-tip pen, which I used for shading. The brown Conté pencil sufficed to indicate the orange pantile roofs.

When I had finished the sketch, before closing the sketchbook I inserted a spare sheet of paper between the pages to prevent offsetting from one page to the other, and once home I used a fixative spray on the drawing. This Burgau subject has been the inspiration for a number of different paintings in various media, one of which, *Algarve Fishing Village* can be seen overleaf. *D/S drawing Conté pencil and felt pen*

Further along the Algarve coast I found another fishing village full of interest, a jumble of building shapes, and varied roof levels interspersed with a variety of palms and yet more washing on the line!

Portuguese Boats

▶ A combination of bright colours, decorative patterns and unusually tall prows are typical of boats along the Mediterranean coast, and this group was a delight to draw. *Ink and felt pen*

Ferragudo

▼ The foreground lamp-posts were added last and super-imposed over the drawing with a strong, thicker line. If I needed to tidy the drawing for any reason, I could touch up the nearest lamp-post with white gouache so that the palm tree doesn't appear to be in front of the post, but I regard this as a working drawing, so I left it as it is.

Pen and ink

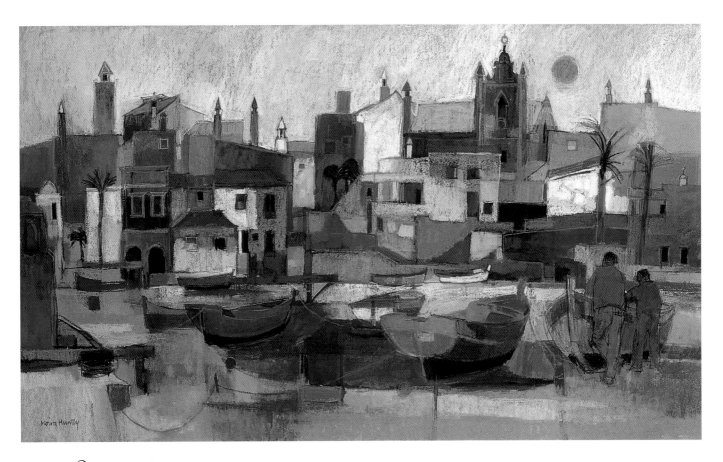

Ferragudo Waterfront

▲ This is one of two pastel paintings based on the sketch overleaf. Here, yellows, oranges and blues predominate along with the infinite mixture of colours in between. The church tower and chimneys have been exaggerated and figures have been incorporated from another sketch.

Pastel, 43 x 74cm (18 x 31in)

Algarve, Fishing Village

▶ In this oil painting inspired by the big drawing of Burgau on pages 70–71, cool colours dominate and warm colours are used sparingly on pantile roofs. Quite a lot of artistic licence was taken when interpreting the sketch so I gave the painting a general title rather than naming the exact location, though you can recognize some of the buildings. My eye level is high as you can see from the distant horizon, but the perspective of the buildings has been kept very simple to help to create an abstract pattern. *Oil, 43 x 53cm (18 x 22in)*

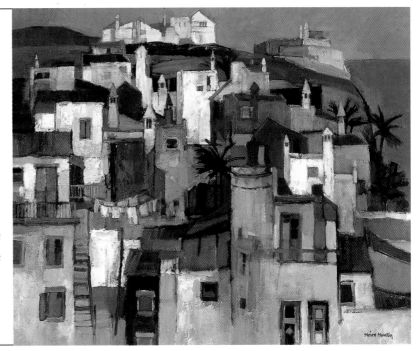

Ferragudo

▶ The complexity of this view of the village and the length of the frontage led me to choose a large A2 sketchbook. I started with the church tower as the highest placed building and mentally allowed enough space below it for the buildings and boats. The drawing gradually progressed outwards from the tower, and the boats were added last. Drawing with a brown ink pen makes a nice change from black ink, and a sense of colour and tone is achieved with the addition of fine pen lines to indicate pantile roofs.

Walking up to the church I noticed that the surrounding railings had lots of posters attached and was surprised to find that they were all advertising a Baden Powell jamboree! I never did find out what that was about. *Brown pen and ink*

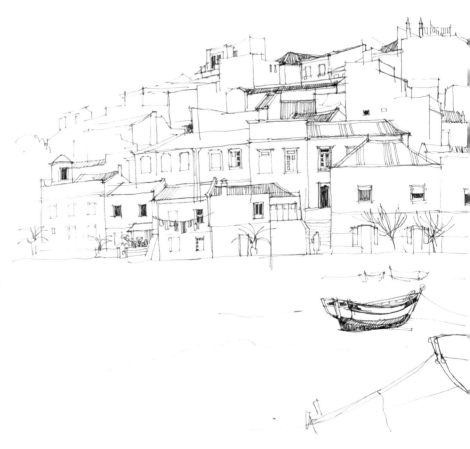

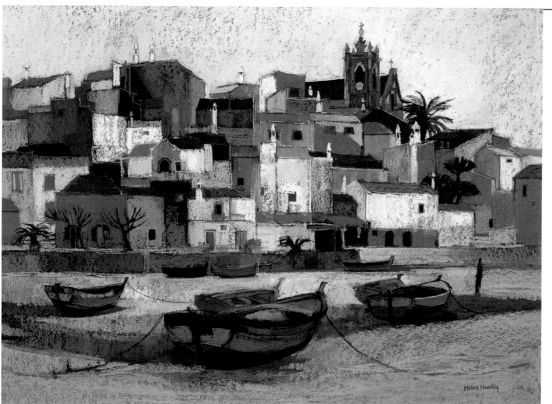

Ferragudo Portugal

◀ A painting inspired directly by the sketch above. The feeling of warmth comes from working on a piece orange of pastel paper. Areas where pastel has been lightly applied allow the paper to show through, as can be seen clearly on part of the foreground around the boats.

Pastel, 46 x 58cm (19 x 24in)

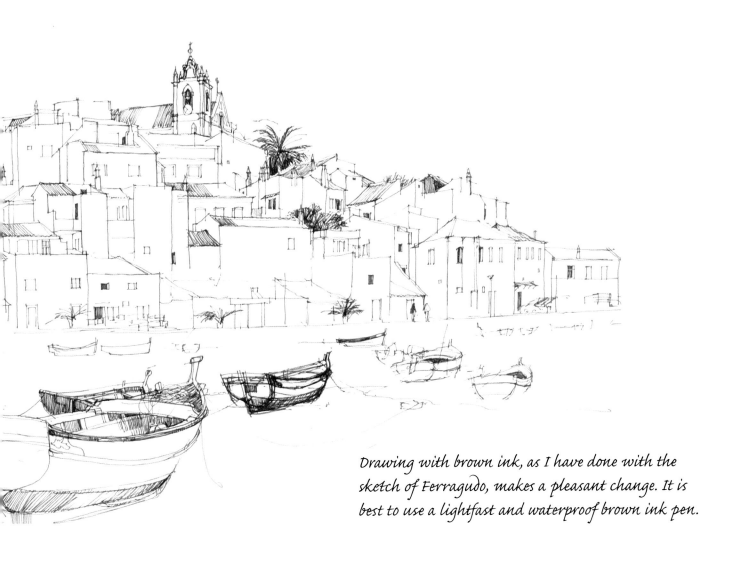

Drawing with brown ink, as I have done with the sketch of Ferragudo, makes a pleasant change. It is best to use a lightfast and waterproof brown ink pen.

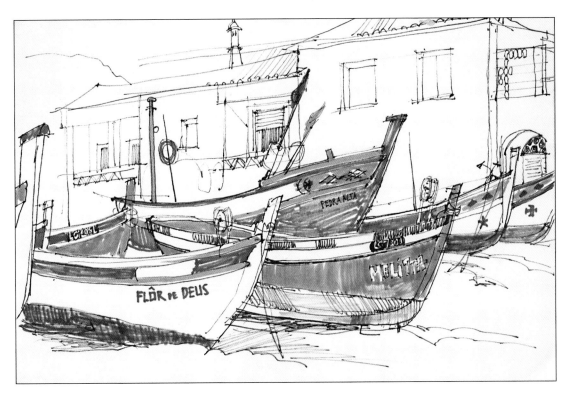

Boats at Salema
◀ The boats are so striking with their varied motifs. I found felt pens very useful to record their bright primary colours, red, yellow and blue plus black and white. *Pen, ink and felt-tip pen*

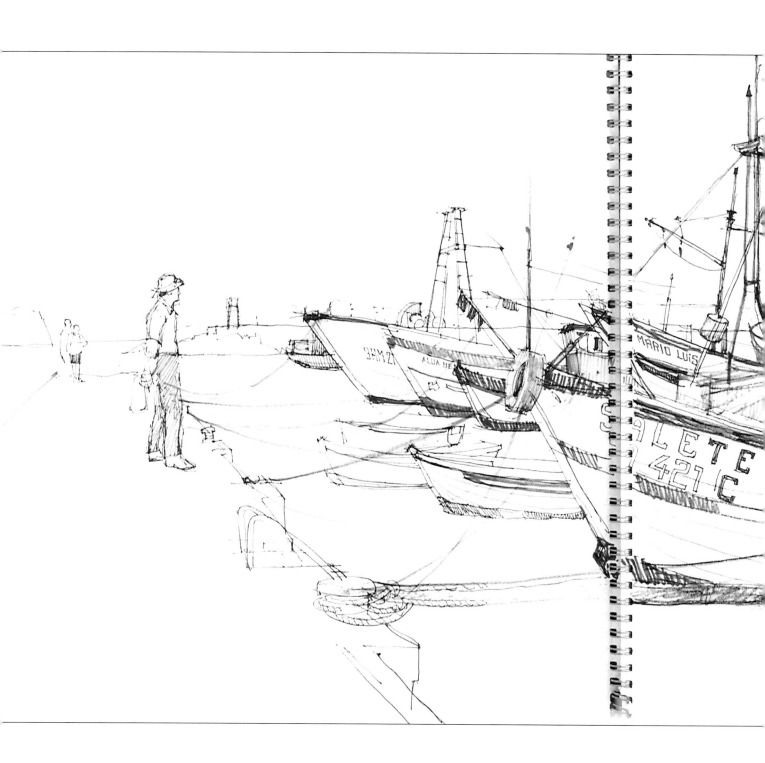

Sagres, Algarve

I used a 48 x 38cm (20 x 16in) sketchbook for this tremendous subject. Sagres is a busy fishing village situated on the most south-westerly point of Portugal not far from Cape St. Vincent. The fleet was in, and in fact there were so many large fishing boats that I was spoilt for choice when it came to choosing a spot for sketching. I decided to draw the *Salete*, and started with the cabin area because that was where the activity was. Most of the

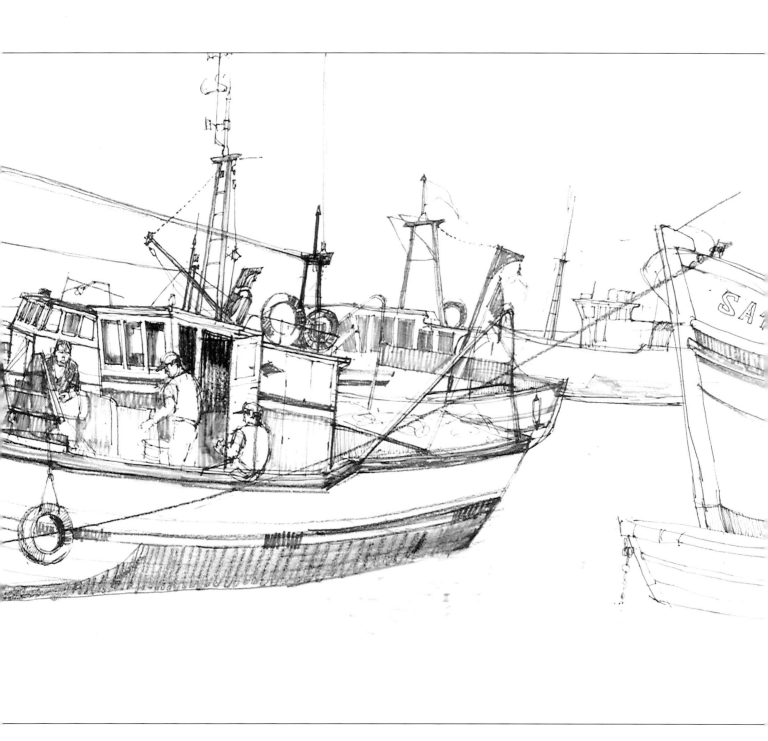

fishermen had gone for a long lunch and I fully expected this crew to do the same and disappear for the rest of the day; but luckily for me, they stayed on board.

Concentration was needed to sort out which mast belonged to which boat. I used a No. 7 drawing pen and Conté pencil to begin with, and then felt pens to indicate the decorative pattern of red and blue of the *Salete*. *Conté pencil and felt-tip pen*

WALES

Wales is an ancient land full of atmosphere, and offers a variety of landscapes that I love to draw and paint. I visit it at least twice a year to seek out stone cottages, slate fences, chapels, green valleys, rocky outcrops, and the grandeur of the mountains that is so visually inspiring.

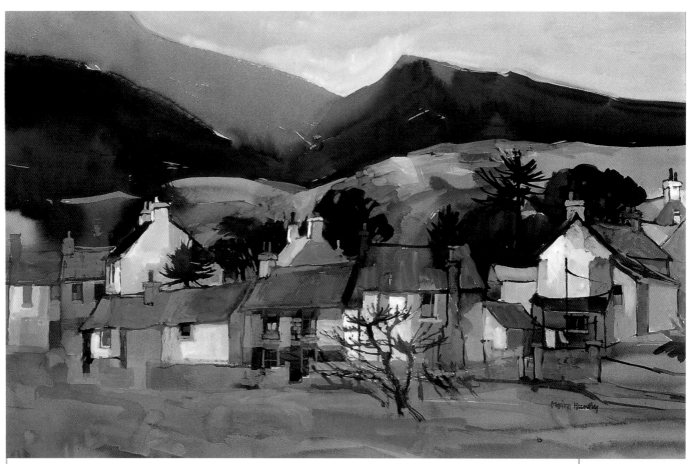

Brynrefail, North Wales

▲ This watercolour was painted in the studio and there is a definite association of ideas at work. I have subconsciously remembered the rainy atmosphere of the day, with cool blues and blue-grey colours predominating in the painting, and I found Payne's grey to be an ideal pigment for the slate colour of the nearer mountain and dark trees. Warm colours are subtle, keeping to burnt umber and sienna rather than anything too strong – a bright orange would have killed the atmosphere. In the foreground the greens are also very understated with only a hint of olive green.

Watercolour and gouache, 36 x 55cm (15 x 23in)

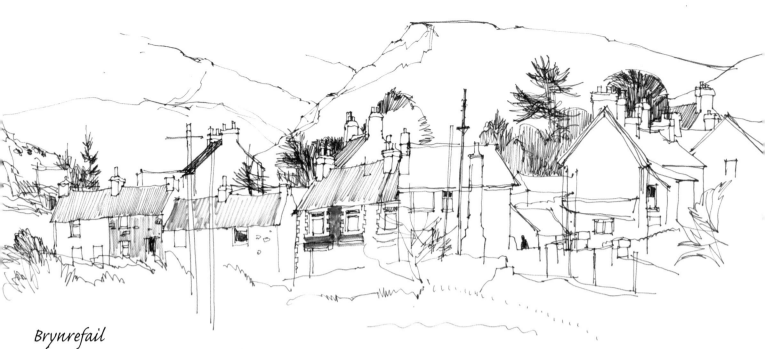

Brynrefail

▲ Brynrefail is a village in the Snowdonia area of North Wales. I was attracted to this row of cottages and houses by the variety of roof levels, the differing shapes of windows – which I see as a pattern – the trees in the background and, of course, by the mountains beyond. I have used this sketch many times as inspiration for paintings in different media, sometimes reflecting the mood of the day when I made the sketch. I recall that it had been raining and was generally overcast; in fact you will observe that part of the mountain profile was hidden behind cloud. *Pen and ink*

North Wales Mountain Stream

▶ This drawing of a mountain stream, the water tumbling down towards the sea from the bare rocky outcrops above, is typical of Welsh scenery. A single windblown tree clings on to the rockface, the only other vegetation being wild grasses. The stream follows a zig-zag path down the sloping ground and an interesting pattern of angular rock shapes emerges. Adding charcoal pencil to the initial pen drawing is useful in creating form and giving structure to the rocks with a gradated tonal shading. *Pen and charcoal pencil*

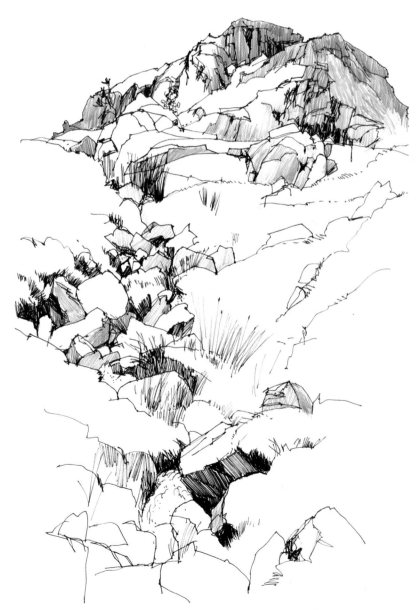

Field Patterns, Y Fron, North Wales

This painting is just what it says, a pattern of fields. It is also a pattern of buildings, colour and tone. Subtle greys, warm greys, green greys, blue greys, slate greys and pale dove greys proliferate on the buildings and the background hills, and are a good foil to the warm colours of the fields. Greens are also subtle, using olive green, *terre verte*, and a soft pale green in the foreground. A bright emerald green would have been totally out of place. The painting was initially composed with abstract shapes, then reference was made to more than one sketch of Y Fron, and shapes were gradually defined as buildings and fields. I enjoy working this way round rather than making a straight copy based on just the one view. *Oil, 48 x 72cm (20 x 30in)*

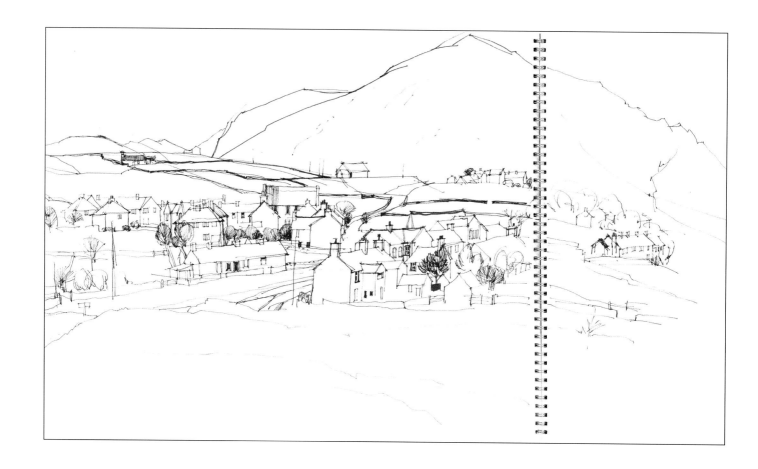

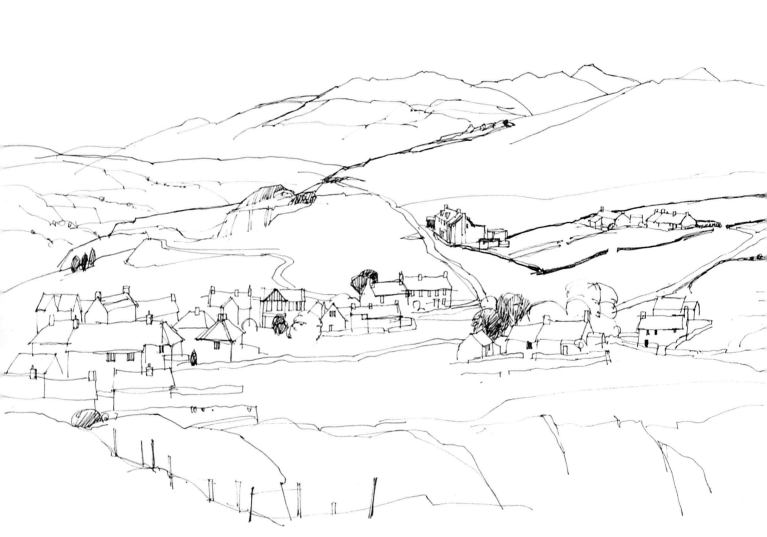

I referred to both these sketches of Y Fron when I was looking for the shapes and patterns that inspired the large oil painting shown on the previous page.

Y Fron, North Wales I
◄ Y Fron is located in a rugged slate-mining area and the surrounding hills seem to tower over the village. Many of the older cottages have fences made from large slabs of slate, and these are fascinating to draw, as you can see in the sketch on the right. These jagged, uneven forms can create dramatic shapes in a painting. *Pen and ink*

Y Fron, North Wales II
▼ This long, thin strip of a village is equally interesting to draw when viewed from the other side. In the foreground is one of the many quarries in the area, and the background hills and fields reveal wonderful undulating landscape forms so exciting to a painter. *Pen and ink*

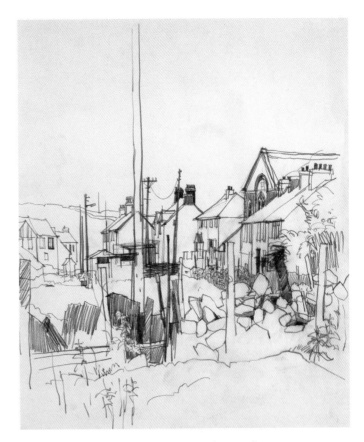

Y Fron, near Cesarea, North Wales
▲ In this drawing there are many of the elements that I associate with Wales: a chapel, slate fence, stone wall, telegraph poles, houses with fat chimney stacks, rusty-roofed outbuildings and nettles. *Charcoal pencil*

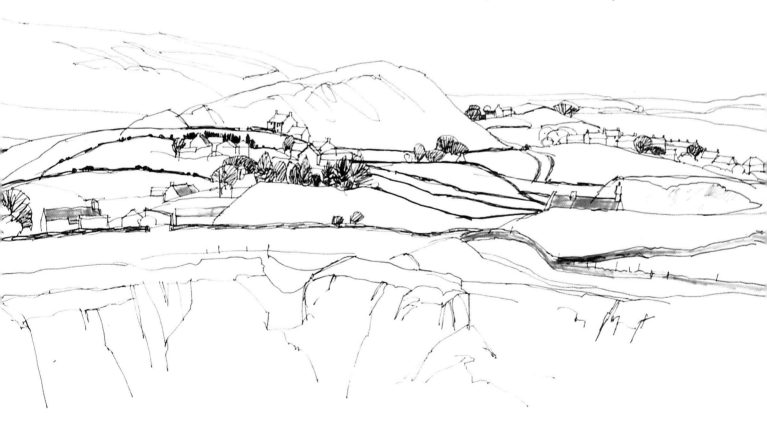

Fields, North Wales

▲ This is a simple line drawing and the simplicity leaves me free to adapt it for a painting in any medium and with my own interpretation of mood and colour. Sometimes I come back to a sketch years later and interpret it with an entirely different colour emphasis, and perhaps a different medium.

Pen and ink

Near Dinorwic, North Wales

▼ This is another freely interpreted painting from drawings made in one of my favourite areas of North Wales. Choosing an extremely dark sky has created drama and contrast in tone. The strong dark of the sky is carried through to the field and groups of trees, and this gives the painting a strong rhythm and pattern. *Watercolour, 24 x 38cm (10 x 16in)*

Storm Clouds Red Fields, North Wales

▲ As you can see, the horizontal sketch has been adapted, and the resulting painting is nearer to a square format. Some of the main characteristics have been retained: the chapels and curving road and the row of cottages on the hill. The mood has been set by using Payne's grey to create an ominous-looking sky, and Payne's grey was also mixed with burnt umber on the background hill.

Cadmium red is used daringly on the fields and cottages and it works well against the other more sombre warm colours in the painting. White gouache was used to pick up light on chimneys, cottages and the road. *Watercolour, 29 x 36cm (12 x 15in)*

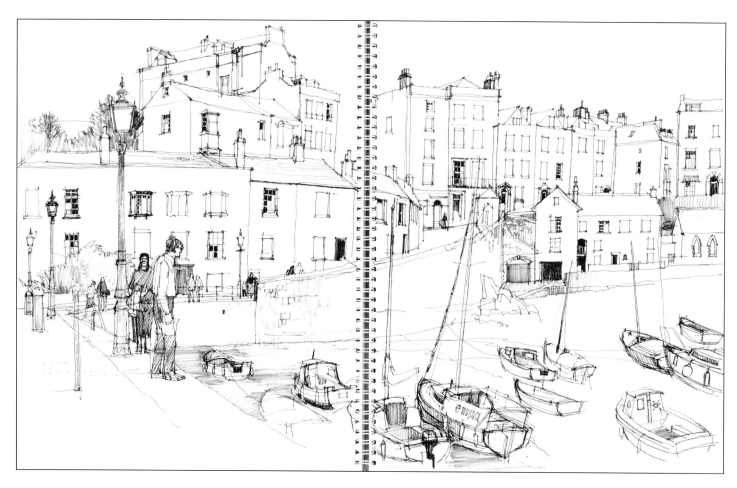

As a family we spent many summers in South Wales enjoying the beaches
and boats, gathering winkles off the rocks, and fishing in the bay for
mackerel for our supper. Alas those fishing days of abundance are over
as there are very few mackerel nowadays.

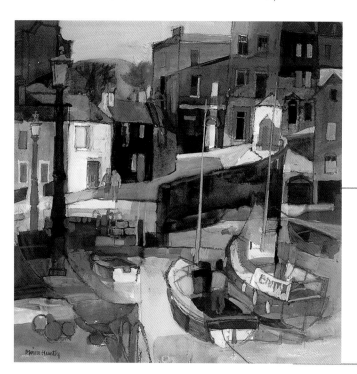

I admit to getting bored with sitting on a beach and
once the family were older, I used to sneak off to sketch
in Saundersfoot or Tenby. Quite often the family would
follow, and there was always plenty of activity to be seen
around the harbours, fishermen mending nets, unloading
catches, and generally pottering about on boats.

Tenby
◄ This is a free interpretation of the drawing above.
Much has been left out in the making of a square-
format painting from a horizontal-format drawing.
The colours are imaginary and quite subdued on the
buildings; the emphasis is on the whitewashed cottages
and warm foreground. *Watercolour, 29 x 29cm (12 x 12in)*

Tenby, South Wales

◄ Attractive buildings cluster around the inner harbour and there are still plenty of boats. I liked the different levels and differences in the architecture. When I drew the nearest figures I related their height to both the lamp-post and the background windows and doors. The height of the distant figures on the harbour wall was also related to the doors and windows behind them. *Pen and ink*

Pembrokeshire Boats

► I used the interplay of freely applied watercolour washes using raw sienna, burnt sienna, brown madder alizarin, and Payne's grey. The latter looks surprisingly blue against warm colours. The boats were defined with watercolour and a fine brush, and also by drawing into a damp wash with watercolour pencils. This gives a nicely diffused line. Touches of white gouache were added to parts of the cabins. *Watercolour, 34 x 22cm (14 x 9in)*

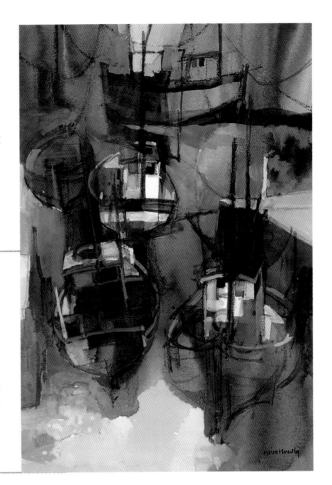

Boats at Abersoch

▼ For me, these boats high and dry on their supports and the floats beneath make exciting visual patterns. I look forward to the prospect of creating a painting.
Pen, ink and felt-tip pen

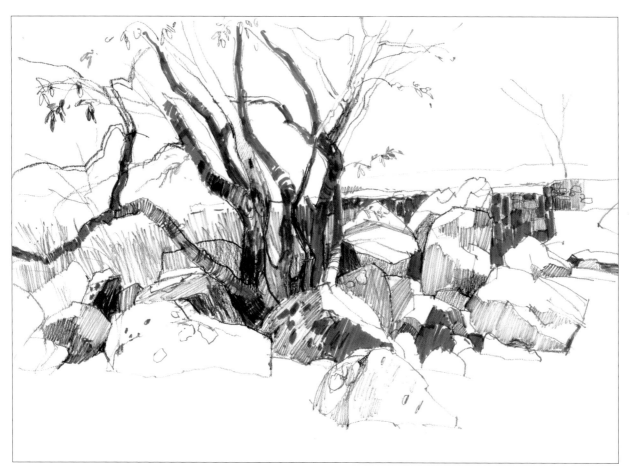

Lakeside Trees

▲ This is a mixed-media drawing using brown, black and pale green pastel pencils, a broad warm grey felt tip and an olive-green felt pen. These colours and textures combine to create an atmosphere that speaks to me of Wales and nowhere else.

To capture the ancient feeling of lichen-covered trees, boulders and rocks I chose a combination of pastel pencils and Conté pencils to give a varied, almost crumbly line and I used felt-tip pens to create soft tones. *Pastel pencils and felt-tip pen*

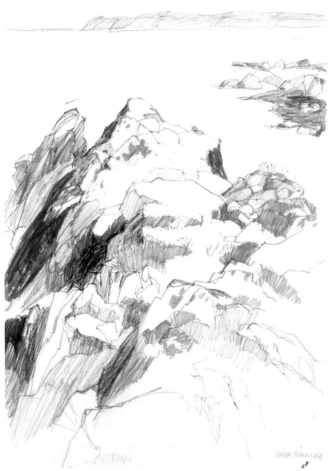

Headland, Lleyn Peninsula

◄ Standing high up and looking over the headland, my eye level is on the same level as the horizon, so I have placed this at the top of the page. This puts the headland into context and creates the impression of distance. I used felt pens in an attempt to capture the rich gold and acid-green colours of grasses and lichen on the rocks. The rock forms are drawn with a mixture of brown and dark grey pastel pencils and with a warm grey felt tip.

Pastel pencil and felt-tip pen

Penmon, South-East Coast, Anglesey

◄ A black Conté pencil seemed ideal for depicting these ancient rocks on the shoreline. Some might even be pre-Cambrian. I made full use of variations in pressure to create 'lost and found' edges and strengthen the rock forms where necessary. At the top of the rocky bank a lone figure stands sketching the distant priory. *Black Conté pencil*

Anglesey Beach

▼ The colours are light and airy, and the palette is restricted, mainly many hues of yellow deepening to a ginger colour; these are the colours of sunshine. The painting is based on the sketch seen on the left with Penmon Priory in the background. *Pastel, 36 x 34cm (15 x 14in)*

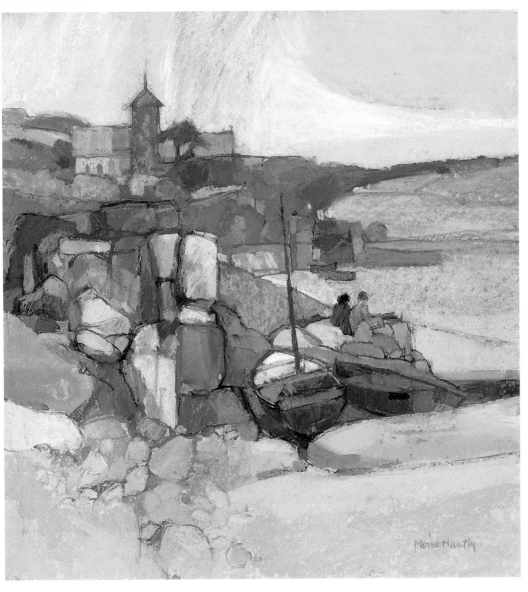

The coal industry used to be present in almost every valley in South Wales, but nowadays most mines are gone with only a few remaining as heritage sites. Some years ago I made a series of coal-mine drawings, usually on grey, rainy days. Quite often I would find that a studio painting made many years later would reflect this mood. An association of ideas, maybe?

Coal Mine

▼ Wales would not be complete without a drawing of a coal mine. This one is in South Wales at Blaenavon, and like so many nowadays it is no longer a working mine and has become a visitor centre. I still have some of my early drawings of working coal mines, not knowing at the time that they would become a rarity. *Conté pencil on grey-toned Canson pastel paper*

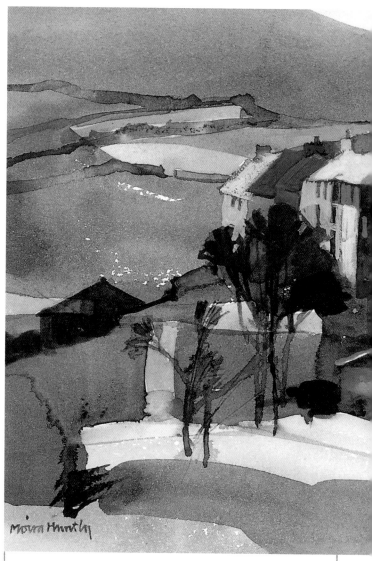

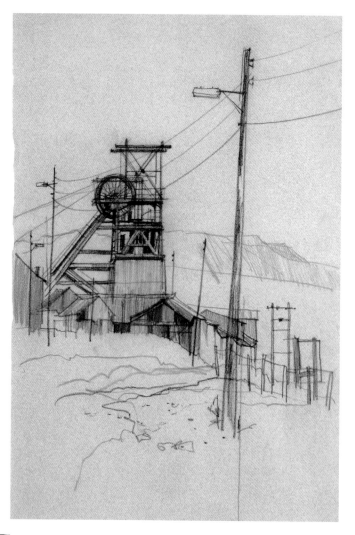

Cwmtillery, South Wales

▲ Soft colours, olive greens and blue greys predominate in this painting of part of the village with its strings of terraced houses clinging to the hillside; the valley was once part of an industrial area before coal mining died out. The painting is a subtle interpretation of the drawing on the right. *Watercolour, 19 x 36cm (8 x 15in)*

Cwmtillery

▶ Only two colours have been added to the pen line, but by varying the tones of each colour it has given an illusion of a much wider range of colour. It hints at rows of colour-washed terraced houses with the occasional bright orange chimney. *Pen and felt pen*

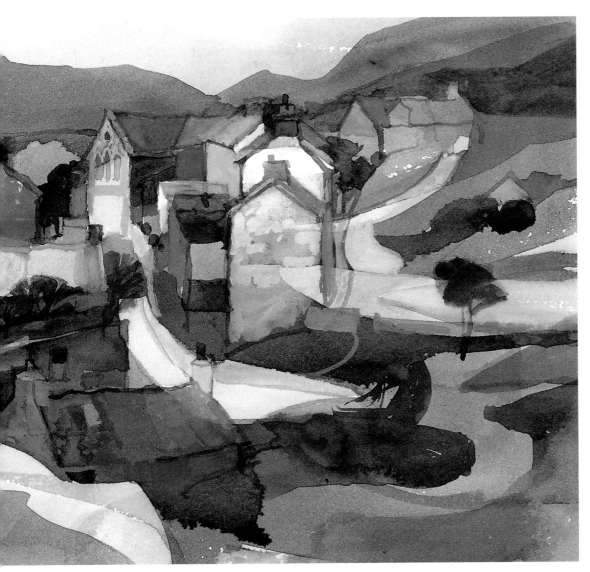

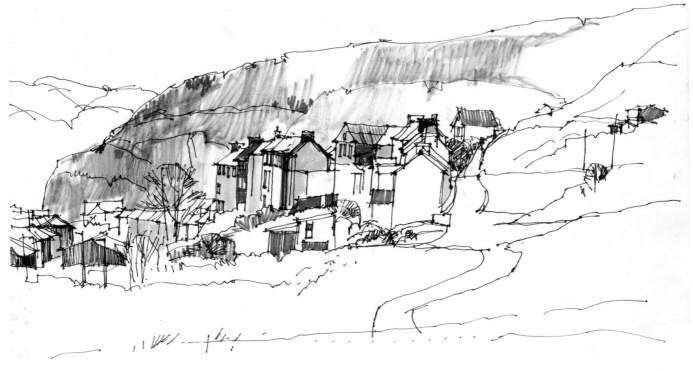

NORTH COUNTRY, UK

I often travel north and a favourite destination is Yorkshire, which is the largest county in England with a diversity of landscape that is immense. There are gentle dales and wild moors, sandy beaches and weathered cliffs battered by the North Sea, ancient fishing villages and rural villages built of local stone. And then there are the limestone walls, some extending at great length to criss-cross the hills and moors.

Some of the fishing villages on the North Sea coast are only accessible by foot, and this has helped to preserve their character. One of my favourites is Staithes, surrounded by rugged cliffs with slate-roofed and red-roofed buildings, steep steps and alleyways, and sloping cobbled streets leading down to the sea. An inner harbour gives shelter to many colourful boats, providing subjects that are enormously attractive to artists.

Staithes from the Lifeboat Station

▼ This is an interesting group of buildings tumbling down to the water's edge, and dominated by rugged cliffs behind. I was particularly attracted to a narrow yellow colour-washed building towards the centre, and this was where I started the sketch. *Pen, ink and felt-tip pen*

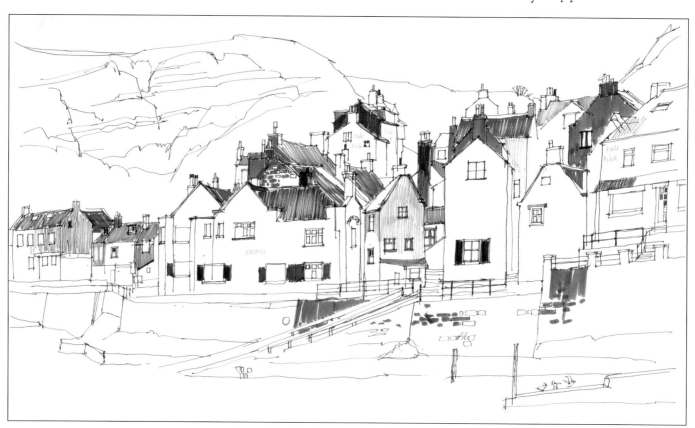

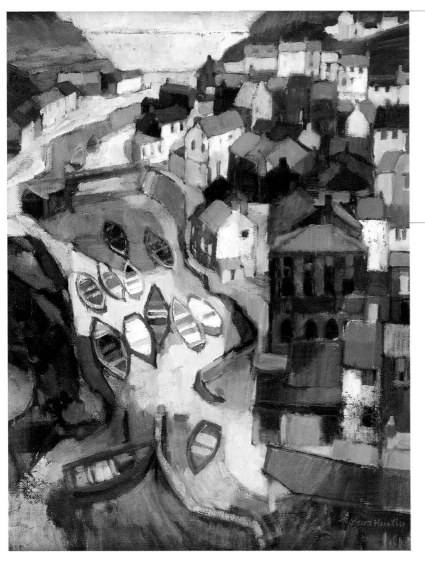

Staithes Harbour

◄ You will see the whole panorama of this village on the drawing that spreads across pages 96 and 97, but in composing the painting I chose to leave out many of the features in the drawing and exaggerate other features such as the boats. Rowland Hilder and many other artists have painted from this vantage point. *Oil, 43 x 34cm (18 x14in)*

The Coast near Scarborough

▼ This is a ten-minute sketch done in a big hurry because it was January. The sky had turned a leaden colour and I could see snow coming in across the sea and settling on the sand around me. I needed some coastline information for a commission and was wishing that the client had chosen a different time of year to send me to the seaside!

The sketch on the top of the left-hand page was also made at this time, and I remember having to grip the sketchbook very tightly and use at least four bulldog clips to prevent the paper from being ripped by the force of the gale. *Pen and ink*

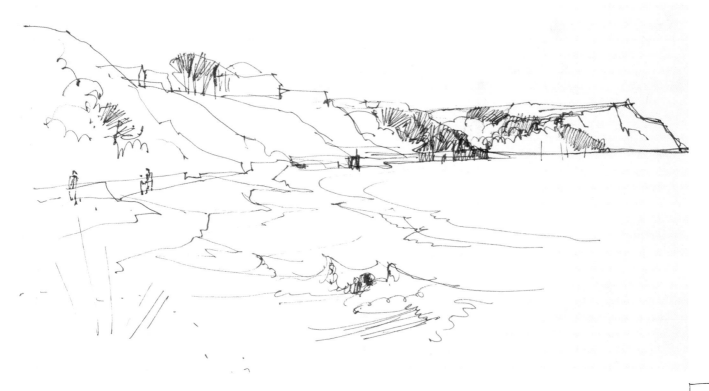

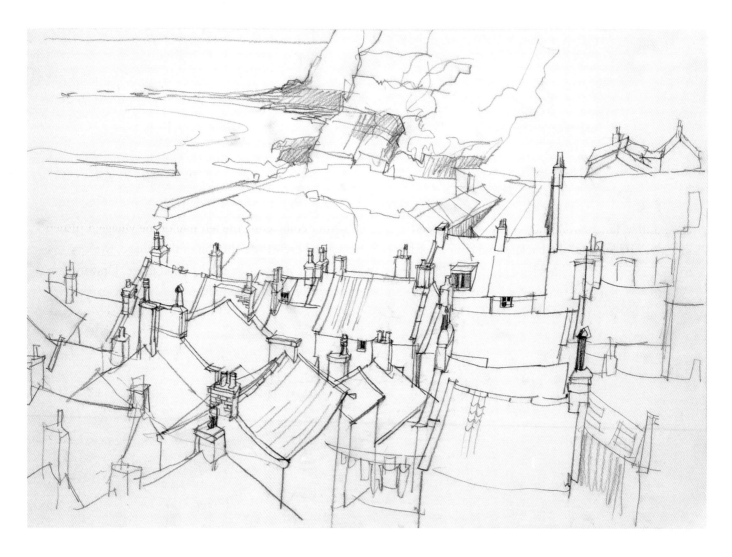

This subject attracted me because I like a clutter of shapes, spaces between, differing levels, and the challenge of observing a complicated group of buildings.

Rooftops, Staithes

▲ I drew this intricate arrangement of rooftops and chimneys with a dark grey Conté pencil, and used a firm pressure on the buildings and a softer touch for the background cliffs. Applying pencil pressure within a drawing can help to create recession and the impression that one object is in front of another, the nearer objects having the stronger lines.

The drawing commenced with the foreground house with the brick chimney stack, then it gradually expanded each side, and I was constantly comparing widths and heights as the drawing progressed.

The more drawing you do, the more you get into the habit of checking spatial relationships. For instance, there is a small dark window in the centre of the drawing, and I looked carefully to see how close it is to each chimney, and how much wall can be seen below the window. I looked at both the shape of the window and the shape of the wall between the chimneys at the same time. I often hold a pencil or ruler out at arm's length to make vertical and horizontal comparisons, looking to see, for example, whether a chimney is in line with another chimney or with the corner of a roof below, and so on. *Conté pencil*

Rooftops, Staithes

▼ Here the colour emphasis of warm oranges and reds has been inspired by the colour of the pantile roofs that are such a feature of Staithes. The composition differs from the sketch – I have been selective and omitted the background cliffs in order to concentrate on the jumble of rooftops. Mixtures of cadmium orange, cadmium red, burnt sienna and burnt umber watercolour create a sense of warmth, and contrast is provided with touches of white gouache on some walls and on the detail of the washing on the line. *Watercolour, 29 x 34cm (12 x 14in)*

Staithes *(over page)*

▶ Drawing the whole village from above was a daunting challenge, especially because there was a gale blowing and I couldn't hold my A2 sketchbook fully open. I had to fold it back, so I commenced the drawing on the left-hand page next to the centre fold and worked outwards. I made a few continuation marks overleaf so that I could eventually join up the drawing.

After completing the left half of the village, I turned over and drew the right half of the village, working out from the continuation marks I had made. Drawing the village as two separate halves was a strange experience, and I hoped that when I was able to open out the sketchbook fully, the village would appear to be properly linked. I think it worked. *Pen and ink*

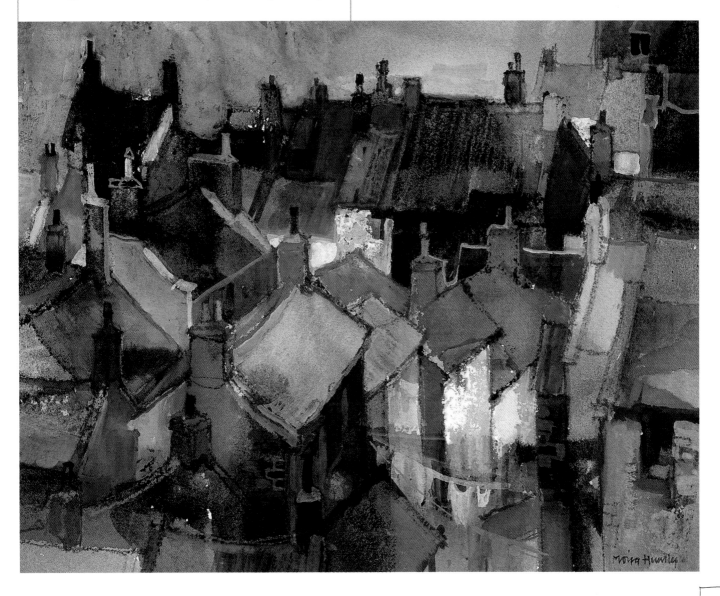

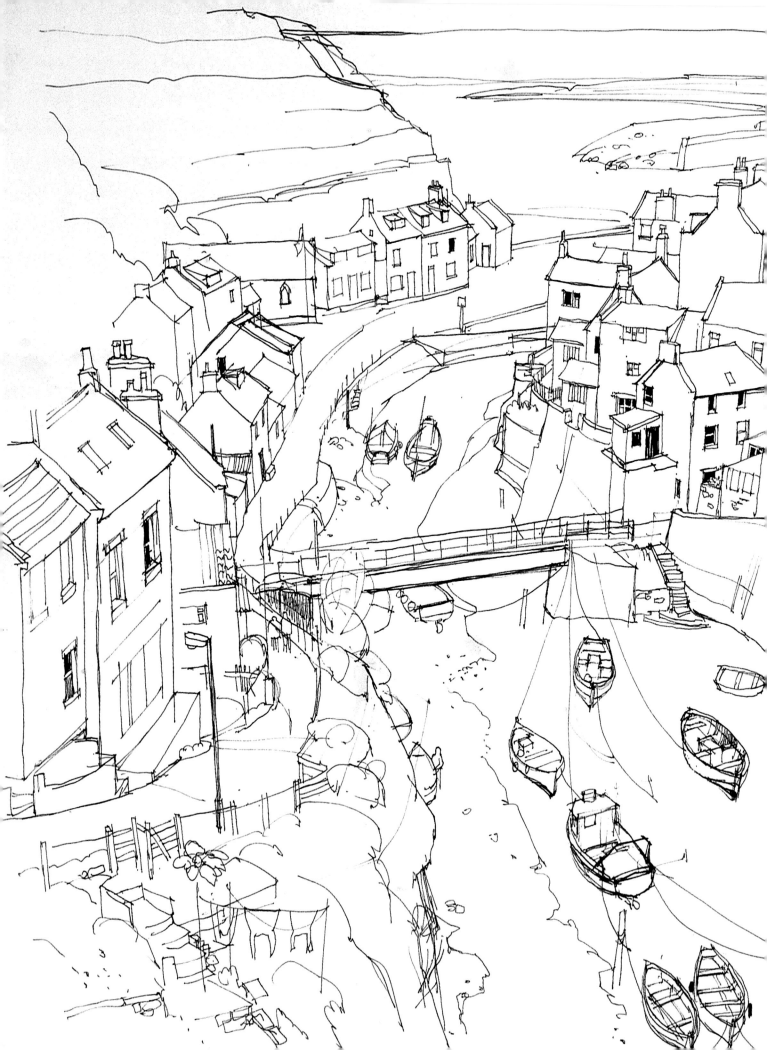

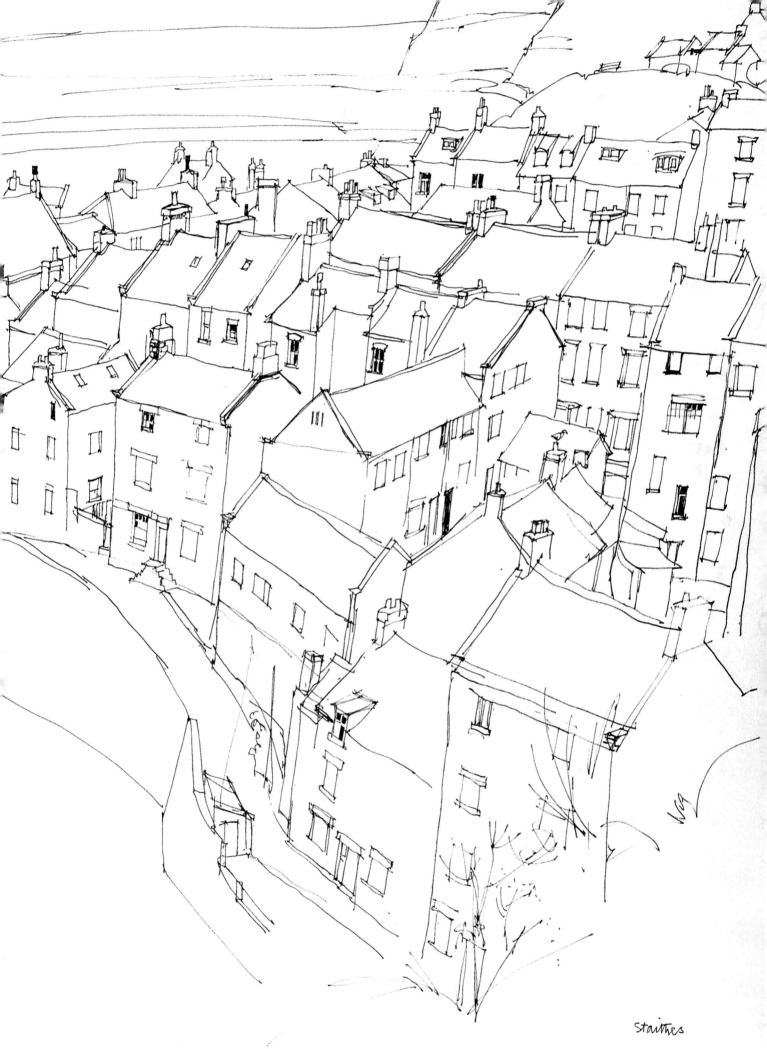

Staithes

Charcoal pencil is a versatile drawing medium and ideal for light and shade, and intense darks. When the pencil is newly sharpened, fine delicate lines can be achieved with the point, and broad marks can be made by shading with the side of the point to create areas of tone.

Farm near Brough, Westmorland

▲ This is a stretch of farmland where drystone walls border the sloping fields, and the surrounding countryside is dotted with clumps of trees. The drawing started with the farmhouse situated at the top of the slope, and then continued downwards with various sheds and farm buildings on different levels in the shadow of the tall trees.
Charcoal pencil and 6b pencil

Coverdale

▶ I used a hard black Conté pencil and a 6b pencil for the sketch. This combination of drawing media enabled me to achieve a variety of tones. There is a play of light and shade; some of the tree trunks are dark against the sky, and light against dark foliage. Similarly, fence posts are sometimes light against a dark bush or dark against a light patch of grass. These counterchanges of tone can make interesting patterns that can inspire a painting.
Conté pencil and 6b pencil

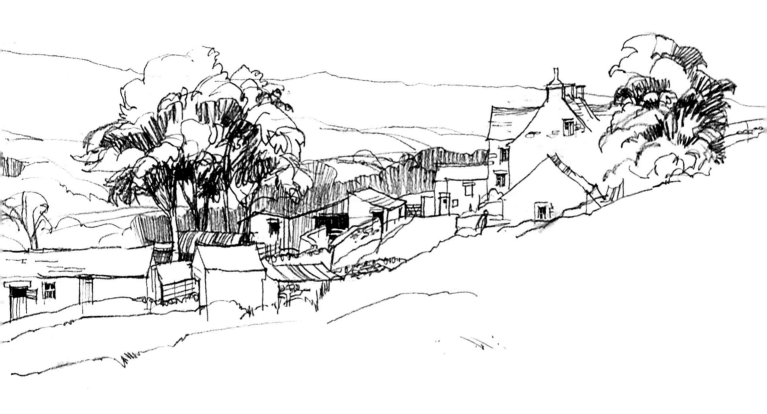

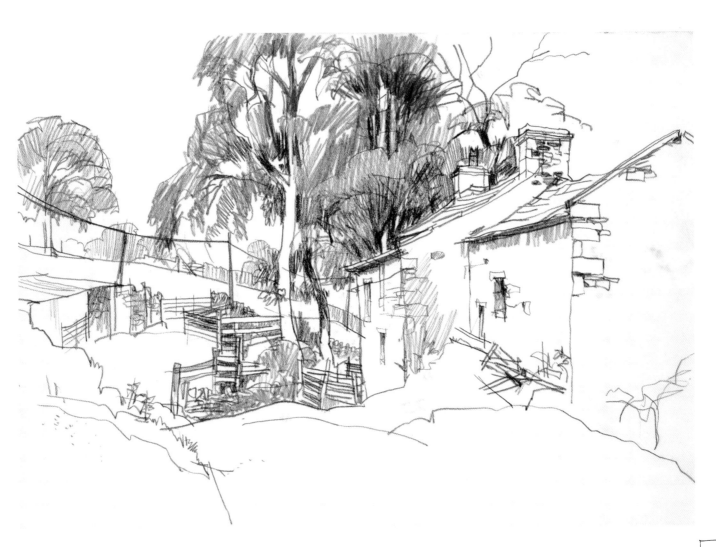

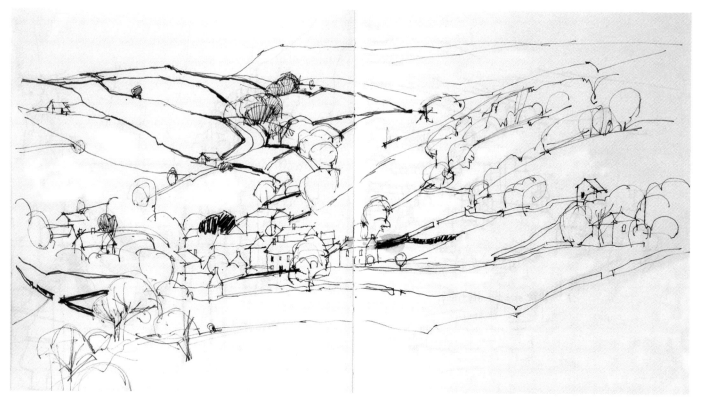

Landscape forms are fascinating to draw, and man-made features, such as stone walls, farmhouses and cottages, seem to adapt to their surroundings and become an integral part of the landscape. The sketch above shows the folds in the hills forming a valley where trees proliferate, and cottages are sheltered.

Landscape near Helwith Bridge

▶ (Above right.) The pencil lines in this sketch have a nice nervous energy as they explore the hills and rock formations in the background. The row of cottages perched on the upper slope with a road winding towards them took my eye. As with so many of my sketches, there is no indication of direction of light. This is deliberate so that if, at some later stage, I decide to make a painting, I am free to interpret the sketch in any way I like. *6b pencil*

▶ Horton-in-Ribblesdale

Rich dark colours in the background are a foil to the light green and yellow pattern of fields that zig-zag their way through the centre of the painting. Clumps of dark trees also create a pattern throughout the painting, and the buildings in the landscape are mostly very light in tone, surrounded by rich dark washes of Hooker's green, burnt umber, burnt sienna and brown madder alizarin. Lemon yellow, raw sienna and a small amount of white gouache completed my palette. *Water-colour, 24 x 34cm (10 x 14in)*

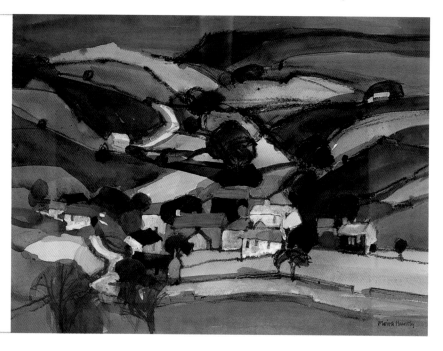

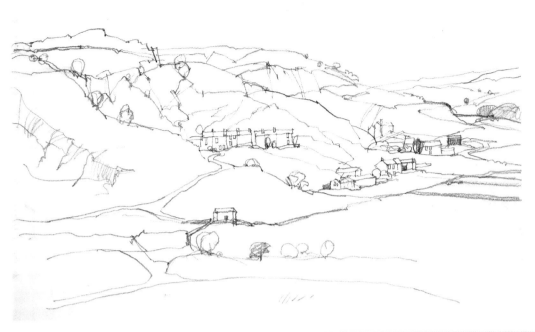

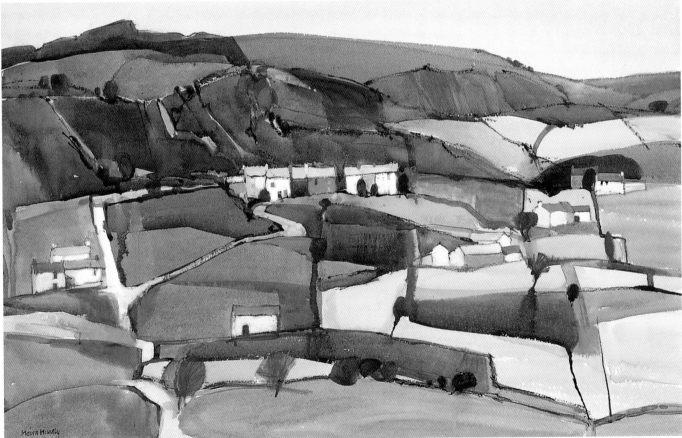

Helwith Bridge, Yorkshire

▲ Yorkshire greens dominate this painting, and some fields glow with many shades of yellow and corn, creating a sensation of warmth from the sun. The sky colour is a simple reflection of this. I was particularly attracted by the row of cottages and

I used some artist's licence and brought the distant quarry nearer so that with the introduction of some white gouache on the buildings, I could give them more prominence against a dark background.

Watercolour, 34 x 53cm (14 x 22in)

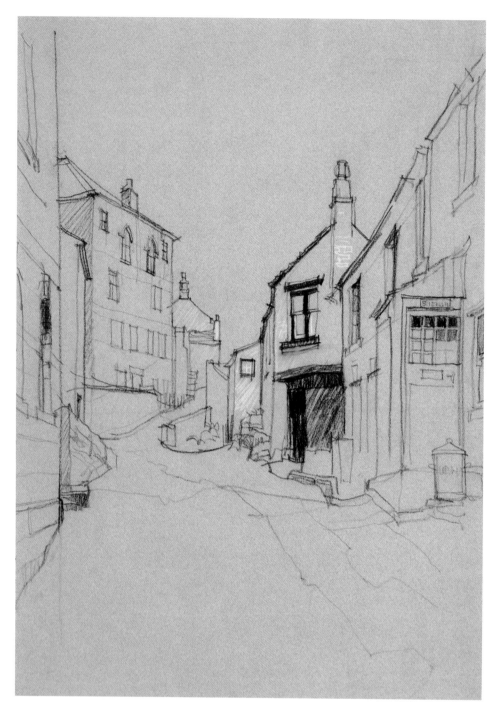

Artists have made drawings on toned paper for hundreds of years. Leonardo da Vinci worked on a variety of coloured prepared surfaces and coloured papers ranging from grey, blue, pink, saffron, green-blue to red, and he drew on these with mixed media, combining black chalk with pen and ink, red chalk heightened with white, and pen ink and wash over black or red chalk.

Turner used coloured paper, often blue, with highlights picked out in white gouache or sometimes pen and ink with white pastel, or pencil on a tinted wash or on grey paper. All these sketching techniques are worth trying.

Staithes Back Street

▲ Black Conté pencil has been used heavily on the black-painted windows and door, and on the pattern of small square windows on the right of this scene. Some parts of the drawing have been heightened with white Conté pencil.

Standing at the bottom, and looking up this steep street, my eye level coincided with the bottom of the dustbin, and you will notice that apart from the walls directly facing me, all perspective lines above the level of the dustbin slope down to an imaginary horizon on my eye level. I was fascinated by the shape of the sky seen between the buildings, and noticed that the shape of the road almost mirrored this. *Black and white Conté pencil on grey pastel paper*

Boats at Staithes

▼ The sun was bright on the day I did this drawing so I used a tan-coloured paper to cut the glare and suggest the warmth of the day. I started the drawing with black Conté pencil, and progressed to coloured pastel pencils to record the colourful boats. Ropes, mooring posts and rocks all add to the design and spatial patterns within this drawing.

Pastel pencils on pastel paper

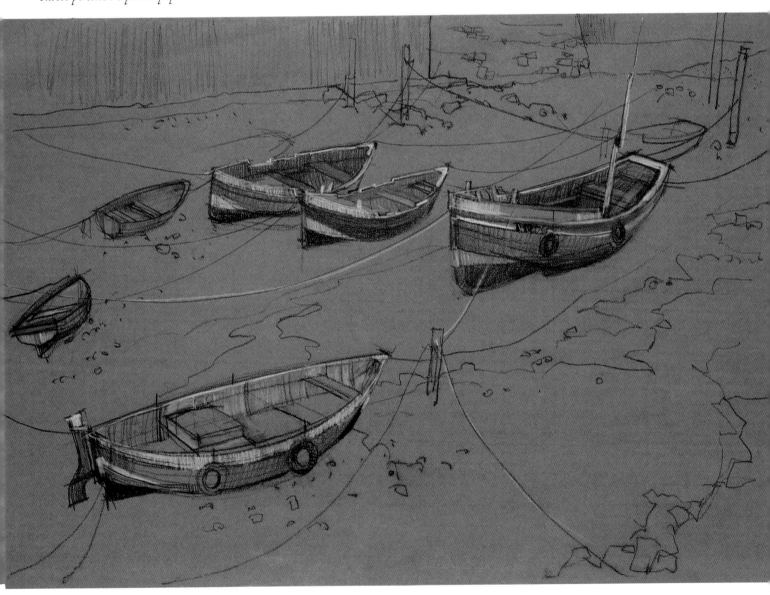

VENICE, ITALY

Venice has deservedly been called 'Queen of Cities'. Visually stunning, its magical atmosphere has always been a magnet for artists. The colourful distinctive architecture and busy tracery of canals with their many bridges never fail to stimulate and excite the visual appetite. I prefer to visit Venice in the Autumn when it is not too hot, and I search out subjects in back streets that are off the main tourist track. You can usually find a sketching place to sit where you are hardly noticed, and in busy places I try to get my back to a wall, which is also a good idea from a security point of view.

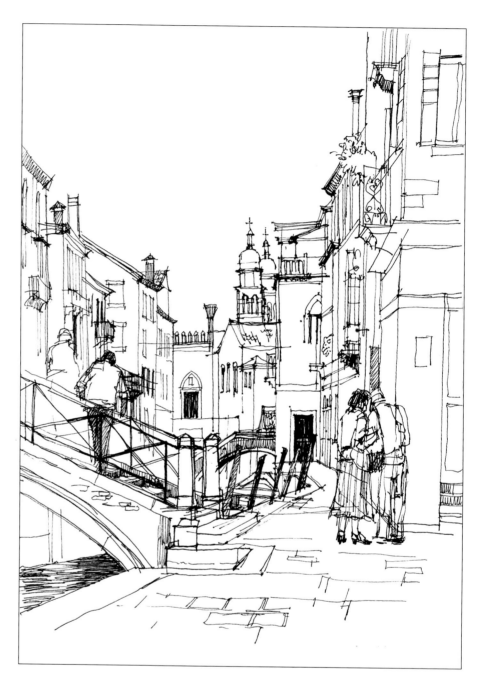

San Barnaba

▲ The architecture in this quiet street, within walking distance of St Mark's Square, is wonderfully diverse and decorative with balconies, chimneys, windows and doors of varying design and glimpses of domed towers. Bridges over the canal also vary in design.

Pen and ink is a medium that requires some confidence but that soon comes with practice. Unwanted lines can be drawn over with a stronger line as you can see on my drawing. Two figures appeared as I was in the process of drawing the building on the right, so I superimposed them, but most of the initial building lines are not too obvious. Such things do not worry me, since I regard this as an exploratory working drawing.

Pen and ink

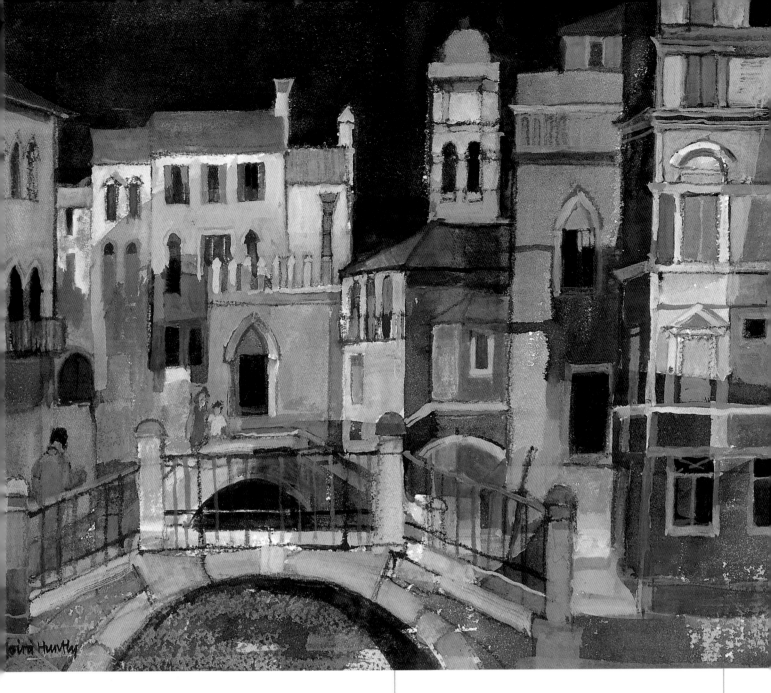

Three Bridges, Venice

This painting is a capriccio, that is, a fantasy painting inspired by more than one source of information. I have used parts of the San Barnaba drawing on the left, and parts of the drawing of Ponte Della Squera (seen on page 108).

A deep indigo sky creates drama and serves as a good contrast to the buildings. The colours used are also a fantasy, being entirely from the imagination.

Watercolour, 24 x 31cm (10 x 13in)

▶ Here you can see how the figures have been superimposed over the pen lines at the base of the building.

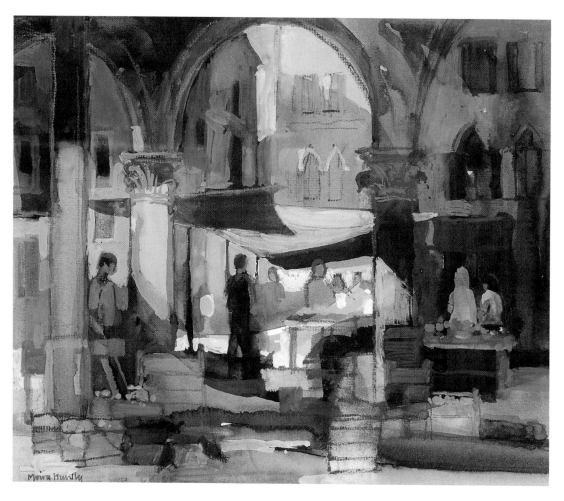

Campo de la Pescaria

▲ The fish, fruit and vegetable markets in this area
of Venice near the grand canal are a popular location
for many artists. There is a fascinating combination of
colourful awnings and produce, and an interplay of light
and shade, especially on the figures, which is constantly
changing. Sometimes the figures appear in silhouette
against the light and sometimes they are catching the
light in full sun. Stone pillars supporting high arches
makes an admirable setting for market subjects.
Watercolour, 19 x 24cm (8 x 10in)

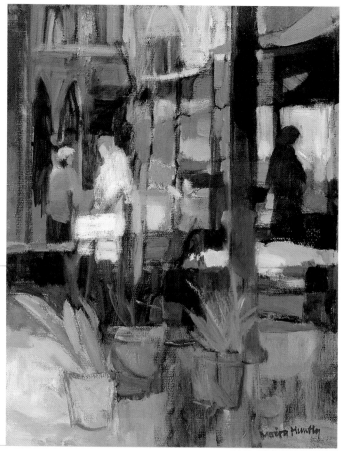

Venice Market

▶ Strong contrasts dominate this painting; the dark
outline of the figure on the right is conspicuous against
the light area behind. Similarly the figures left of centre
show up conspicuously against the dark background.
When colours are soft and muted, tonal contrasts give
strength to paintings. *Oil on board, 24 x 19cm (10 x 8in)*

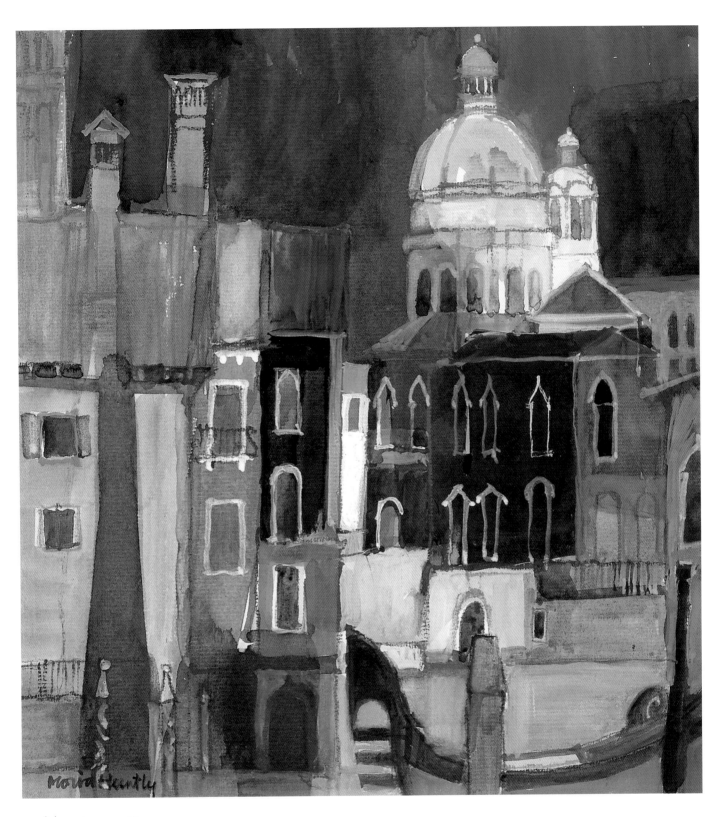

Golden Dome II
An imaginative painting inspired by sketches of key elements that represent Venice, such as domes, decorative architecture and chimneys, the prow of a gondola, and a kaleidoscope of rich colours.

Watercolour, 26 x 24cm (10¼ x 9½in)

When I returned to Venice after a gap of many years I wondered if I would be disappointed, but far from it. The city never changes, it loses none of its attraction, and there is something to sketch around every corner. The Ponte Della Squera area was no exception with its buildings and curious chimneys, ornamental street lamps and bridges.

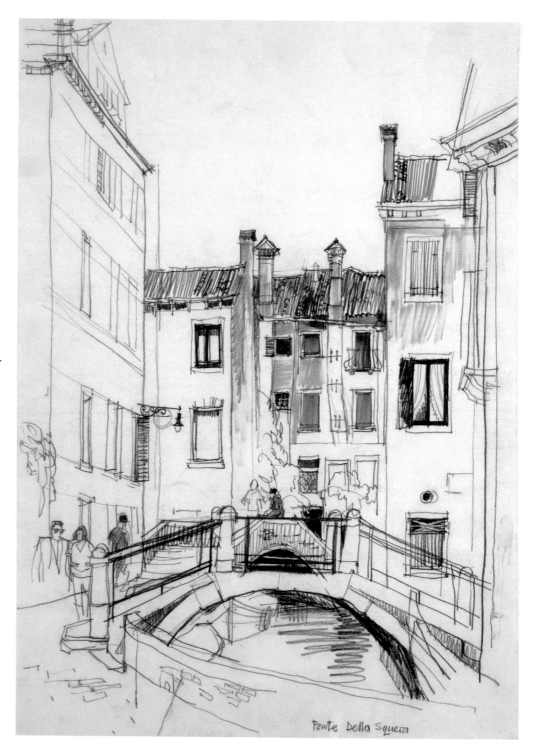

Ponte Della Squera

Ponte Della Squera

▲ When tackling a subject such as this, with buildings opposite each other, I constantly refer to the height and width, asking myself questions such as: 'Is the height of the building greater than the width? Is the level of a window on the left-hand building higher or lower than a window opposite?' I observe subtle differences in the heights of chimneys. I also compare the height of a figure to the height of the nearest door. Would the person be able to walk through the door without bumping their head? It is easy to get people out of proportion in a drawing. *Conté pencil and felt-tip pen*

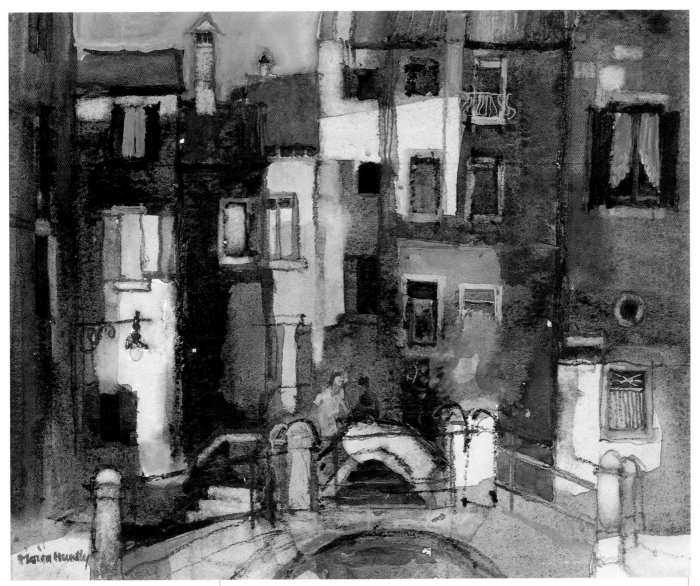

Corner near Ponte Della Squera
▲ This interpretation of the sketch started with washes of raw sienna
to give an overall warmth to the subject, then was given freely applied
washes of cadmium orange, burnt sienna and ultramarine blue. Although
this is a limited palette, as soon as strong darks were added with mixes of
burnt umber and Hooker's green, the resulting effect was to give a richness
to the whole. Touches of detail were added with watercolour pencil.

Watercolour, 19 x 24cm (8 x 10in)

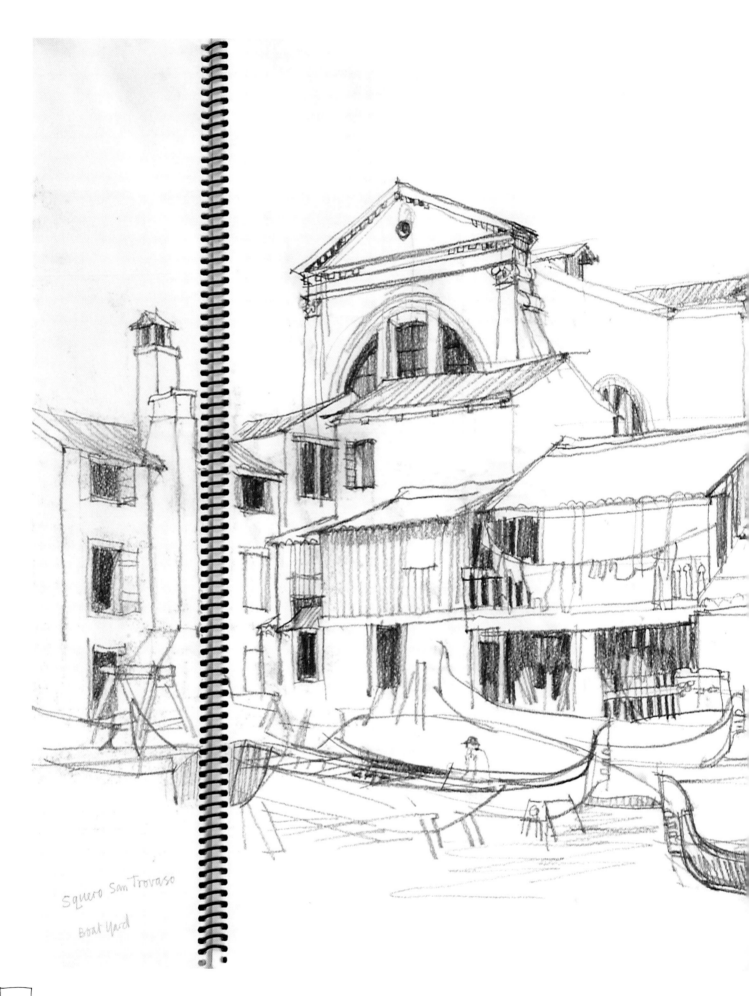

Squero San Trovaso
Boat Yard

Squero San Trovaso Boatyard

This is another very interesting and busy corner of Venice, with plenty of boatyard activity. Before I started the drawing I tried to make sure that the whole of the view I had selected would fit on the paper. There were many different features that I wanted to include, and to ensure that I didn't run out of space I chose an A2 sketchbook. I can draw fairly rapidly with a charcoal pencil, and the soft quality lends itself to conveying light and shade and texture. *Charcoal pencil*

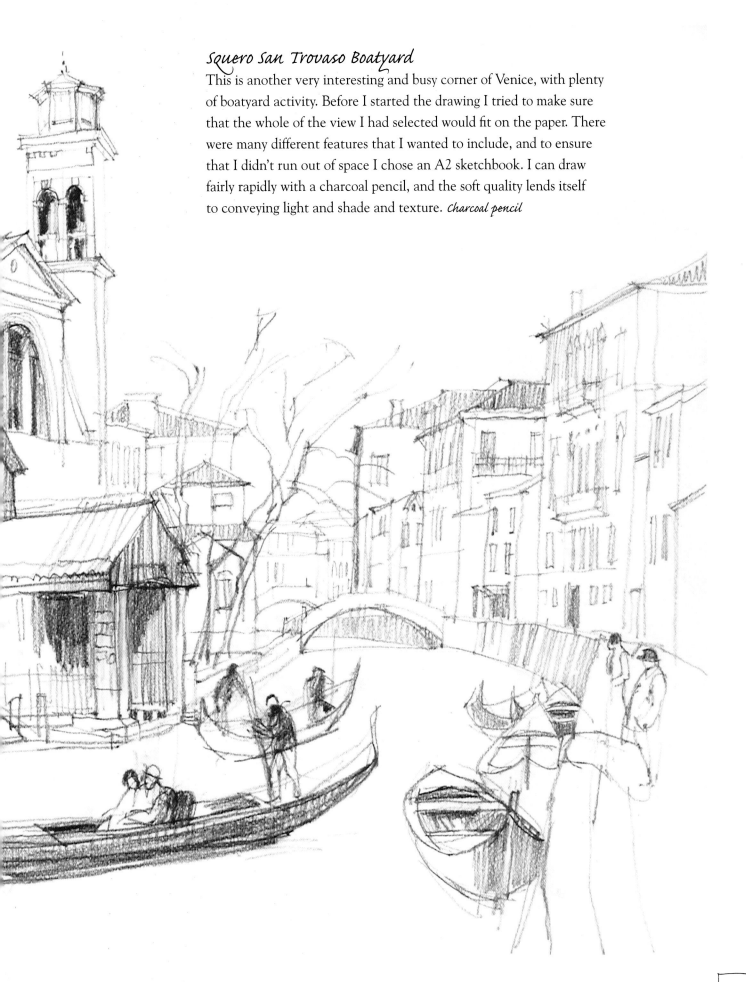

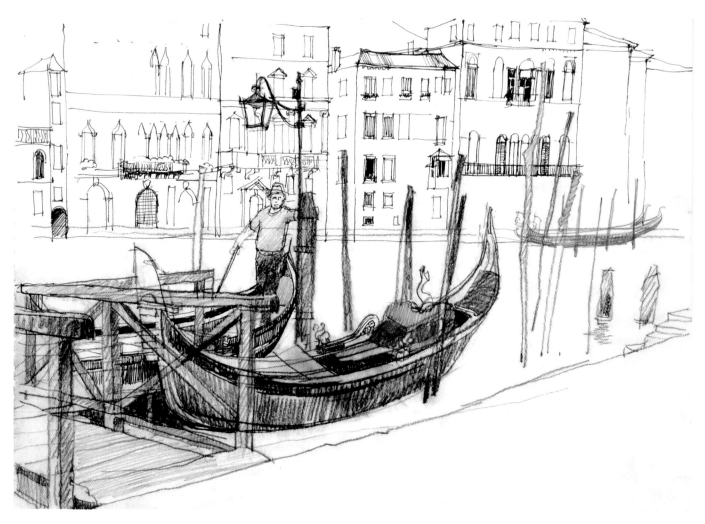

The Grand Canal from the Fish Market

▲ There was a momentary lull for the gondoliers, so I took the opportunity to do a sketch. It was quite difficult because the gondolas kept bobbing up and down on the water. I liked the decorative lamp attached to the mooring post and the row of colourful buildings on the other side, apparently rising from the canal waters. The numerous mooring posts in the sketch provide a good compositional link between the foreground and background. *Pen and ink, charcoal pencil and Conté pencil*

Gondolas are beautifully elegant in design, and unique to Venice. I believe that it was in the 16th century that all gondolas were ordered to be painted black, but the seating is splendidly decorated, the cushions often a rich crimson red and the gondoliers wear colourful costumes. The elegant lines of the gondolas are, however, deceptively difficult to draw.

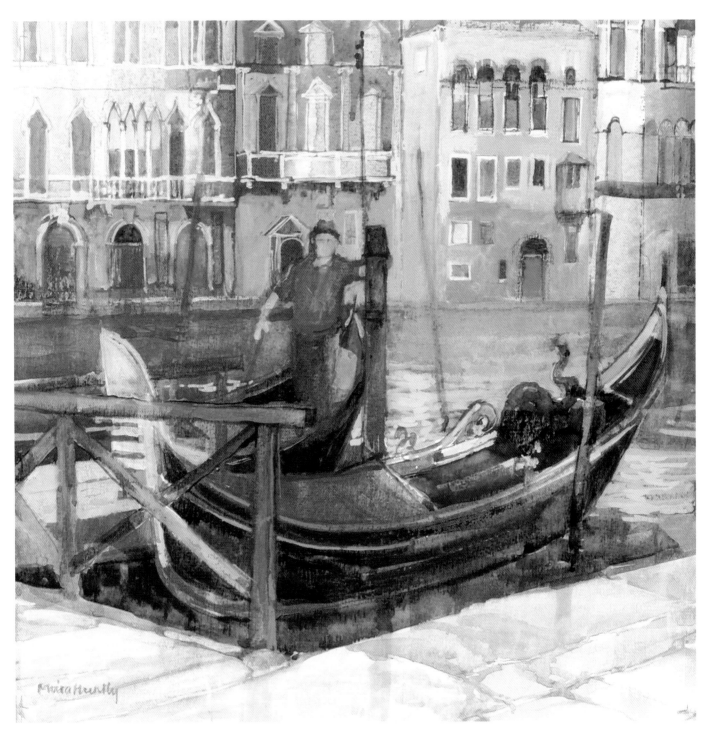

Gondolas, Grand Canal, Venice

◀ After drawing the prow of the gondola I decided to add the handrail. There is no attempt to tidy up the drawing because I do not think that the superimposition detracts from the overall effect.

▲ Much of the colour in this painting is subtle, but underwashes of vermilion permeate the painting and show through the overlays of thin gouache paint. This creates an overall feeling of warmth that is accentuated by the red of the gondolier's shirt. Some of the background buildings glow with soft reds, yellows and pinks. *Watercolour and gouache, 29 x 29cm (12 x 12in)*

Calle de la Pescaria

▶ The unusually tall archway between two buildings and the washing on the line immediately took my eye as a subject that would make an interesting painting back in the studio. Dark green and light green shutters and turquoise awnings shading the street cafés all added to the visual interest that can be exploited in a painting.

Pastel pencil on Canson pastel paper

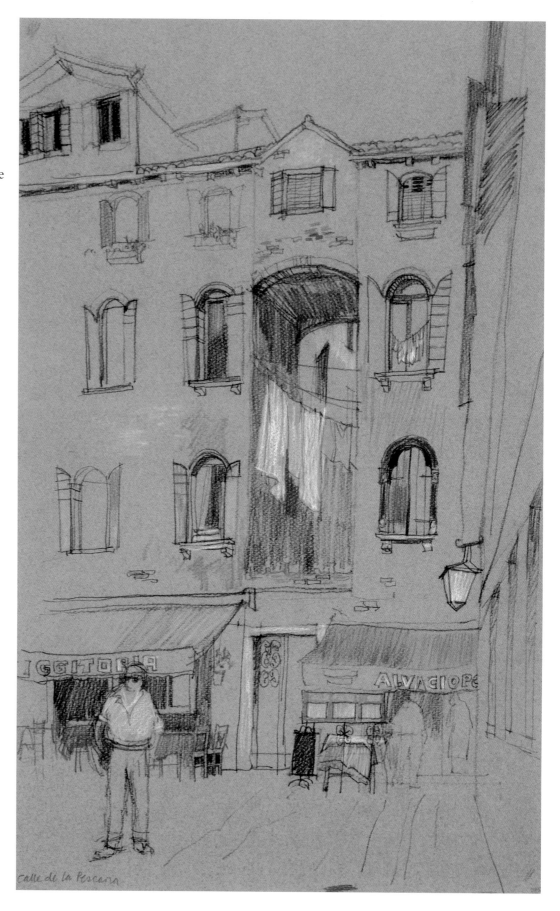

It was a hot sunny day and I found it helpful to use a toned paper to cut glare so I could draw the lights as well as the darks. Colour notes with pastel pencils will enable me to recall the scene.

People are fascinating to draw. A market place is ideal because people stop to look at the goods on display usually long enough to be sketched. And when one person moves on, you can usually adapt the sketch to include the next person that arrives, because there is often a repetition of movement.

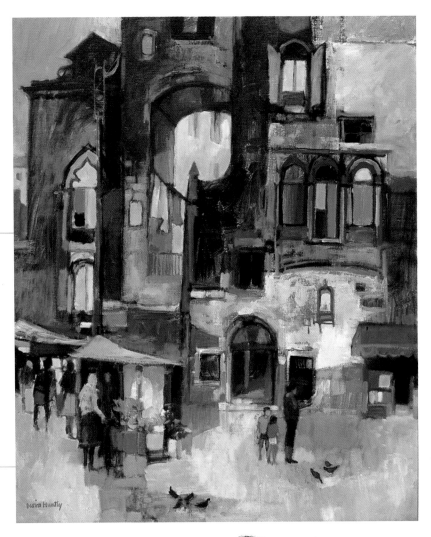

Near Calle de la Pescaria

▶ This is another capriccio painting. By that I mean a painting that combines subjects taken from different sketches. Here I have included subjects typical of Venice: market stalls and figures, architectural features, birds on the pavement, a deep blue sky, and my favourite archway with the washing hanging beneath, seen in the sketch on the left. *Oil, 55 x 46cm (23 x 19in)*

Marketplace

▲ These simple groups of figures were drawn quickly to capture the general stance, and details were left to add later. Obviously the nearest figures are largest and the position of the feet is low on the page. You will notice that as figures recede the feet are drawn at a higher level on the page, but the heads remain mostly on the same eye level. This is because these figures are of average height. The exception is the taller figure on the right. *6B Pencil*

November Light, Venice

▼ Soft subtle colours and a very limited palette give this painting a wintry atmosphere.
Sepia hues dominate, relieved by touches of pale turquoise and grey green. A bright
colour would have been out of place. *Watercolour and gouache, 48 x 41cm (20 x 17in)*

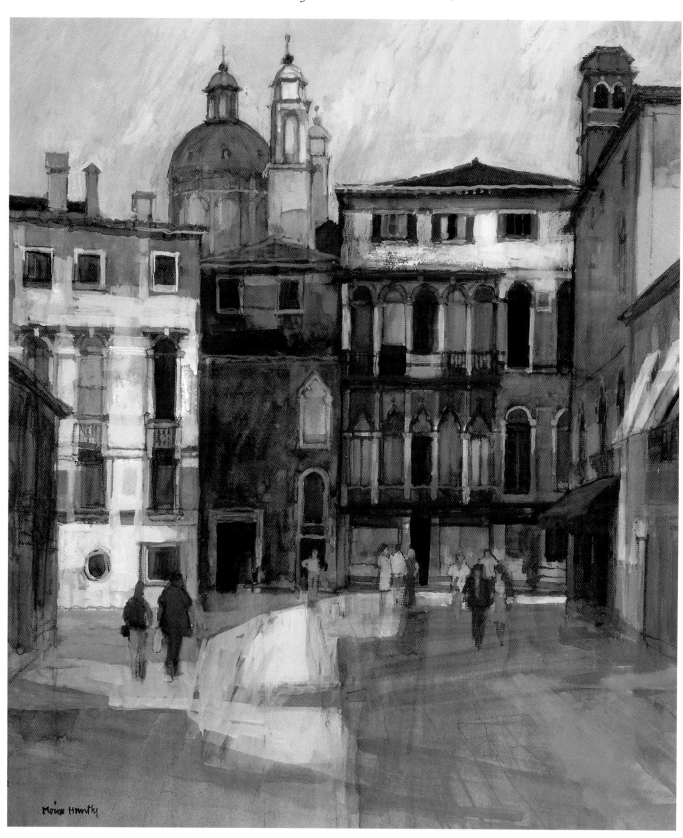

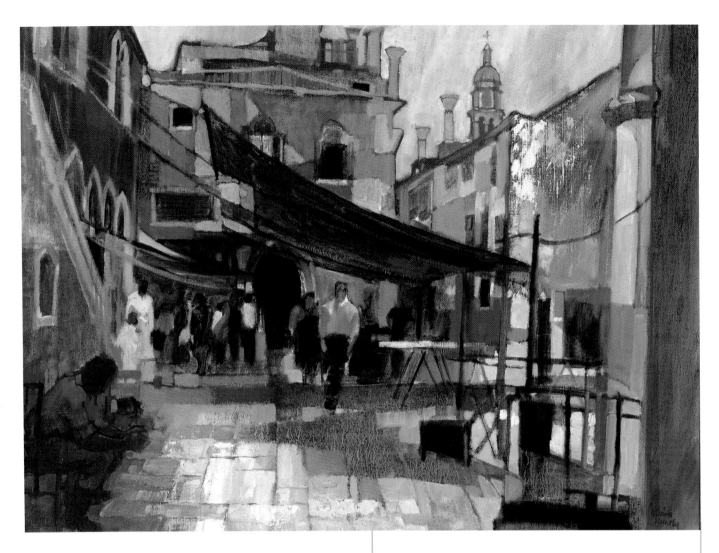

One of the most memorable and touching experiences I have ever had whilst sketching took place in Venice. I was concentrating hard and looking up at a beautiful building ahead, when I realized that a group of nuns had stopped in front of me. I wondered for a minute if I was trespassing. They looked to see what I was doing, then one of the nuns stood in front of me full of praise for the drawing and proceeded to bless me and then bless the drawing. As you can imagine, I was totally overcome, and it was some time before I was able to regain my concentration. It was a humbling experience, and one I will never forget.

Fish Market, Venice

▲ This painting also has a limited palette, but unlike the wintry scene opposite, these colours have a summery atmosphere. The colours are complementary, that is, they are found opposite to each other on the colour circle, in this instance mainly red and green. Much can be gained from a restricted palette and an immense range of colours can be achieved by mixing the two colours in various proportions. Adding white and black to the mix can extend the range even further. *Oil, 43 x 58cm (18 x 24in)*

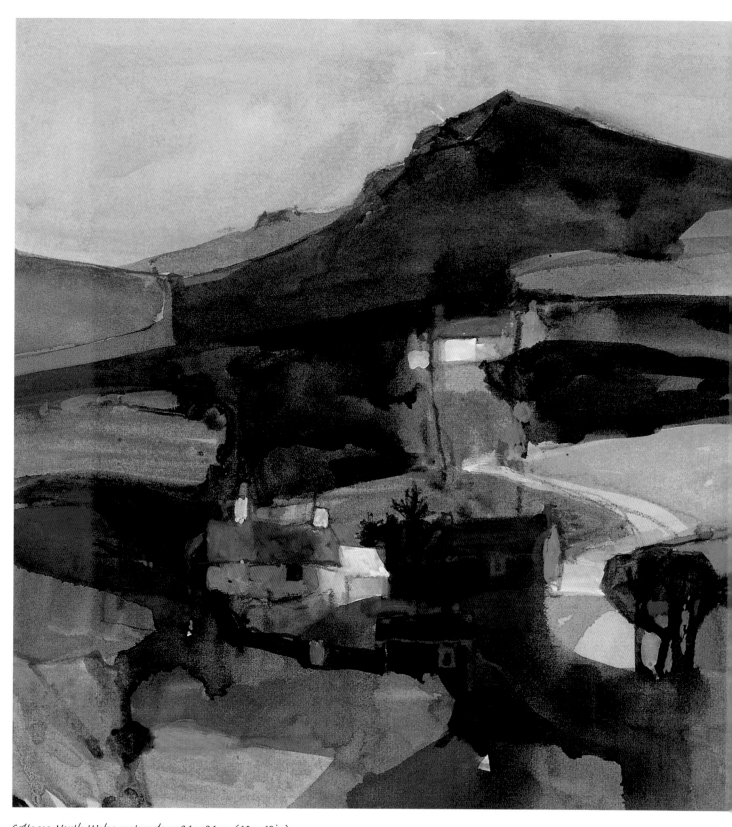

Cottages, North Wales, watercolour 24 x 31cm (10 x 13in)

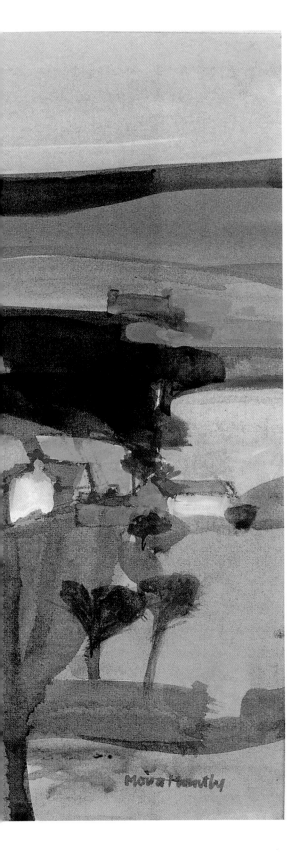

Conclusion

Sketchbooks are like a private personal diary, recording things seen and places visited. They are not usually intended for publication, but in writing this book I have tried to describe my way of working and share my innermost thoughts. I have always had an instinctive desire to draw, and enjoy the act of drawing for itself. Over the years I have accumulated a large number of sketchbooks that I find invaluable as reference for paintings. I try to record accurately, and at the same time am looking at a subject for the visual patterns that appeal to me and could be the basis for a future painting. Often a drawing will bring back a memory of the day and influence the mood of a painting. I hope that some of the ideas in *Sketchbook Secrets* will be helpful, but always do things your own way, sketch what you want to sketch, and don't forget that if you are dissatisfied with what you may think of as a 'failed' sketch or painting, it can nevertheless be progress of a kind.

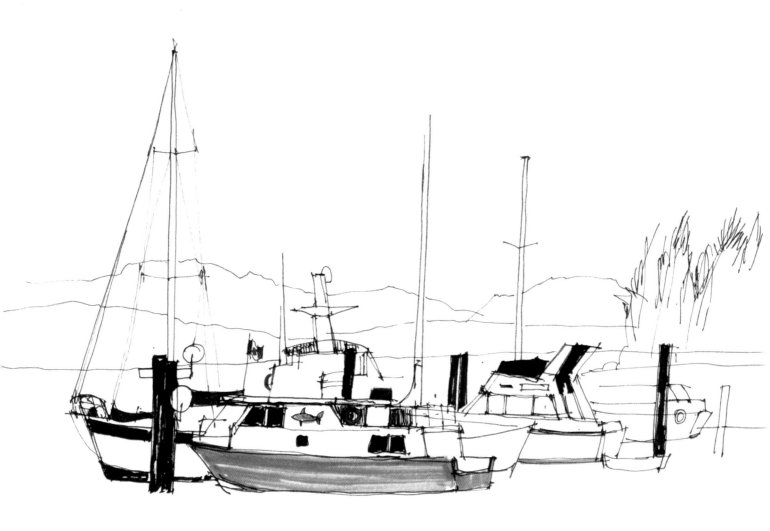

Acknowledgments

My thanks to Ian for all his support, editor Mic Cady for his enthusiasm, to Karl Adamson for patiently photographing well thumbed sketchbooks, and to John Bryden whose inspiration and ideas made this book possible.

Index

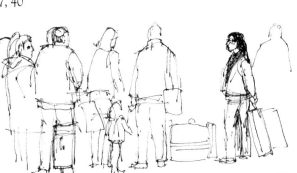

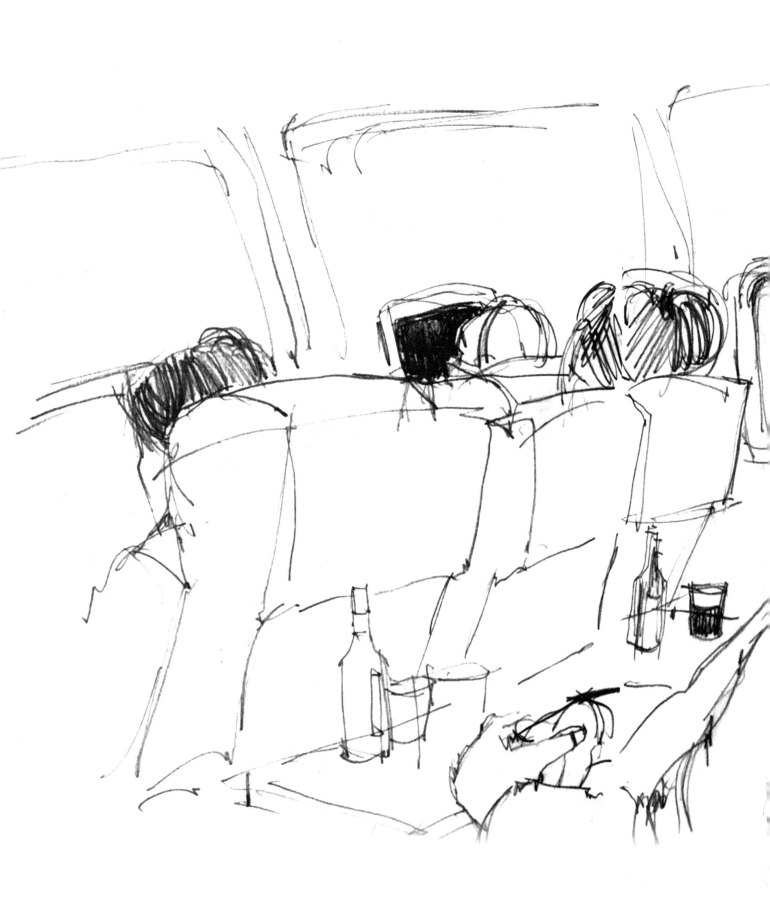